In the Name of
GOD
and
RELIGION

Other Books by the Author

1. Assassination of Ziaur Rahman and Aftermath (2009); United Press Limited Dhaka Bangladesh.
2. Fight for Bangladesh (2011); Xlibris, Indiana, USA
3. Forty Years of Bangladesh (2012); Xlibris, Indiana, USA

In the Name of
GOD
and
RELIGION

Born Again Jihadists of Modern World

ZIAUDDIN M. CHOUDHURY

Copyright © 2017 by Ziauddin M. Choudhury.

ISBN: Softcover 978-1-5434-1654-1
 eBook 978-1-5434-1653-4

All rights reserved. No part of this book may be reproduced or transmitted in any form or by any means, electronic or mechanical, including photocopying, recording, or by any information storage and retrieval system, without permission in writing from the copyright owner.

Any people depicted in stock imagery provided by Thinkstock are models, and such images are being used for illustrative purposes only.
Certain stock imagery © Thinkstock.

Print information available on the last page.

Rev. date: 04/24/2017

To order additional copies of this book, contact:
Xlibris
1-888-795-4274
www.Xlibris.com
Orders@Xlibris.com

Table of Contents

1. Foreword .. ix
2. Intolerance -- Wearing Religion on the Sleeves 1
3. Islam, Islamist, and Islamophobia 8
4. The Challenge of Religious Radicalism 13
5. An Islamist War in the Middle East 18
6. Fury of Militancy and Bloodbath in Pakistan 22
7. Collaterals of Terrorism .. 26
8. Bloodshed in Brussels and Angst of Muslims of the West .. 30
9. Orlando Massacre ... 34
10. Cannon fodders of the terrorists 38
11. Carnage in Paris- the beginning of Apocalypse? 42
12. Drawing a Line in the Sand 46
13. From Arab Spring to Arab Winter: Future of Democracy in Muslim Countries 51
14. In the Name of God and Religion 56
15. Iraq War Version Two .. 61
16. Misadventure of Muslim Youths Abroad 65
17. Terrorism in any name is bad as it sounds 70
18. Terrorism- the ultimate bigotry 74
19. What You See is What You Get 78
20. Was Middle East better off with dictators? 82
21. US Conundrum in Syria .. 87
22. Terror in Dhaka-- the inevitable happens 92

23. The stalled war against Islamic militants 96
24. Morsi's Fall and Impact on Democracy 100
25. Pakistan cracks down on militants 104
26. Obama and the Middle East 108
27. Illusions of secularity and reality of communalism112
28. Coddling Religious Extremists for Political Gains...... 117
29. The Elephant in the Room and Our
 Denial Syndrome .. 122
30. Compromises of Disaster ... 126
31. Sowing Wild Oats of Religious Militancy 130
32. The Roar of the Radicals ... 138
33. Tackling Religious Militancy142
34. US Missile Strike in Syria—Simply a Pin Prick?....... 147
35. Will destruction of ISIS bring an end to
 jihadist fight? ..151

This book is dedicated to my life partner Roxana Choudhury for her support in all my writings.

Foreword

This book is a collection of articles that I wrote over last few years which were published in different Newspapers in Bangladesh. The articles reflect my reactions and thoughts over the senseless atrocities and acts of violence that shook various countries of the world that time (and still continue to occur), in particular the Middle East and South Asia. These acts, purportedly carried out in the name of Islam, shocked the affected countries and their people, but these also put about one and a half billion followers of the religion in jeopardy vis a vis their relationship with other faiths and beliefs. The mindless violence in the name of Islam appeared to increase with the rise of such groups as Taliban, Al-Qaeda, Boko Haram, and lastly the so called Islamic State (ISIS). Their actions were sometimes coordinated with radicalized youths in the West and South Asia with shocking results.

Terrorism is not a new phenomenon, it has happened many times in the past all over the world. The most common kind of terrorism is by an organized group which is either fighting for independence or to advance an ideology or cause like the Maoists in the subcontinent, Basque nationalists in Spain, Sean Fein in Ireland, etc. The other type is lone wolf acts where the individuals have gone on mass shooting of people because they have personal grievances against their government or simply they snapped out.

What is the difference between the acts of terrorism that wrecked Europe and South Asia years ago and those occurring now? Why the perpetrators of terrorism in the past were not identified by their religious persuasion or ethnic identity like they modern terrorists are being identified now? One reason could be that attacks in the past were not carried out in the name of religion as they are being done now. Terror attacks in earlier part and middle of last century had a more limited goal, and usually for a political purpose. The terrorist attacks in recent past (and happening now) are carried out in the name of Islam. The perpetrators of this new terrorism may delude themselves and their followers that they are taking up arms to spread their twisted interpretation of religion, but in reality these are acts of irrational minds.

The rise of militancy in the name of Islam was viewed with awe not only by the western countries where many such terror incidents happened but also, perhaps more catastrophically in largely Muslim countries in the Middle East and South Asia. All Muslim countries have not only despised and abhorred these acts, but have also declared the acts as antithetical to their religion, and have taken measures to tackle this danger seriously. However, despite these anti-terrorist actions, religious terrorism has become a serious threat to democracies all over the world. In addition, the rise of such malignant forces in the name of Islam has also put the followers of this otherwise peaceful religion in the unenviable position of defending their faith against a growing sentiment of Islamophobia worldwide.

The articles, presented in no particular order, are narratives on the damages caused by religious militancy as they happened over the last few years. Since most articles are based on events at the time when these happened some of the narratives may appear to be outdated, but the reactions the events caused in the affected countries and worldwide still reverberate in people's mind. Many political backlashes that resulted from these events are still evolving and will have more consequences in politics and societies all over the world.

The current movement of the so called jihadists, if we can call it a movement at all, is rooted neither in Islam nor does it have any traction among the vast followers of Islam. It is a false movement based on false interpretation of the religion and its doctrines. No movement without mass support can survive for long. While countries gear up to confront the menace of this radical group and take measures to stop its youth from falling prey to such ideas, alongside they will need to raise mass awareness about the falsehood of this radical thought and the danger confronting us all. In Muslim countries such as Bangladesh and Pakistan this will mean more reforms in our educational curricula and educational institutions focusing on teachings of religion, values of life, liberty, and freedom of thoughts. These will also need to be cast in the overall framework of transparency in governance, rule of law, and equality before law of all citizens in the country. May be we can see a better future free from violence for all our next generations if we strive together.

Intolerance -- Wearing Religion on the Sleeves

"And let us reflect that, having banished from our land that religious intolerance under which mankind so long bled and suffered, we have yet gained little if we countenance a political intolerance as despotic, as wicked, and capable of as bitter and divisive"—Thomas Jefferson.

The past several years have not been easy for the Muslim World. Apart from the wars that have been fought in many countries, either voluntarily or involuntarily, political unrests in many Muslim countries over the past two years have ushered monumental changes that were unimaginable only a decade before. Autocratic governments and rulers have been ousted from their bastions of power through popular uprising; people power has toppled military might, and democratic rights have replaced autocratic choice. Even though these momentous changes are still a work in progress, the World has hailed the changes in many Muslim countries as great victories in human rights, ending of oppression, and beginning of a new dawn. What is perplexing however is that along with such welcome political changes that were made possible by people power, there has been also a palpable rise of prejudice and intolerance, particularly with respect to one's religion. And this growth in prejudice is not limited to countries which were recently swept by uprisings against their dictatorial regimes, but others that have a relatively more stable political environment.

The most recent example of this growing phenomenon was the outrage and consequent violent acts that swept most of the Muslim countries of the world over the purportedly inflammatory documentary on Prophet Mohammed made by a demented amateur videographer in the US. The documentary was never exhibited anywhere in the world, but a sneak preview was made available by an unscrupulous person in the internet to incite people vulnerable to such provocations. This was enough to ignite protests from the Middle East to Africa, to South and East Asia where people raged in the streets, burnt property, killed innocent people, and demanded death of not only of alleged perpetrator but also punishment of the countries that allegedly sheltered the perpetrator.

Right on the heels of this massive protest sweeping the Muslim countries came another case of indignant protest, this time in Bangladesh, with tragic consequences. As in the case of the derogatory documentary, the ignition of this protest was also effected through the internet and use of social media to propagate a false report of insult to the Prophet by a member of the Buddhist community in a far flung corner of the country. None cared to check the veracity of this allegation. Instead, armed goons launched attacks on the Buddhist minority brethren for their alleged complicity in the alleged insult to the Prophet, burnt their temples, and destroyed their property. This attack was unprecedented in the history of the area as the two communities have lived in harmony for centuries there respecting each other's religion and culture. Yet, when all this mayhem was taking place it

seems odd that saner elements of the majority community could not stop this violence for fear that they would be seen as supporting the alleged culprit who "insulted" their religion.

A few months before a similar situation occurred in Pakistan. In a village not far from the country's capital, a minor Christian girl was hounded, and jailed, on the allegation that the girl had burnt pages of the Holy Koran. The whole community rose up in arms and the girl was prosecuted on the basis of this allegation of blasphemy that later turned out to be false after police investigation. No one from the majority community bothered to verify the allegations, perhaps from fear that they appear before their more militant neighbors as condoning this act.

Indignant reaction to insults to one's faith or belief is understandable; but it becomes indefensible when such indignation leads to wanton violence and endangerment of people's lives and property. A couple of years ago a Danish cartoon of our Prophet caused violent reactions in the Muslim countries. However, instead of protests through more civilized means that could be more effective, the rage and anger of the protesters took an extreme proportion causing more damage in the countries where the protests were held than in Denmark.

From time to time we have incidents where individuals or groups who either wittingly or unwittingly take to acts that hurt the religious feelings of another community.

Unfortunately the reactions in our parts of the world to such gratuitous acts of individuals are often violent, deadly, and self-defeating. Instead of addressing a wanton act of provocation by an individual in a clever and more productive and helpful way we project an image of greater intolerance and bigotry with violence.

Intemperate response to perceived affronts to one's religion is one thing, and perhaps can be explained with some stretch to venting of suppressed feelings toward countries that are not considered friendly by some Muslims. But this does not explain intolerance and violence in one's own country not only between practitioners of different faith, but between sects within the same faith. In the subcontinent we had witnessed much of this intolerance in past decades, both before and after partition fought by communities of two major faiths ostensibly for religious reasons, but in reality for manipulation for political purposes.

Over last decade or so, however, we have been witnessing intolerances of other kinds that are of a more sinister dimension. People professing same faith have fought deadly battles with their co-religionists on sectarian grounds. In Pakistan, Sunnis and Shias continue to fight deadly battles for adherence to their mutually different interpretations of the same religion. The most recent case of religious bigotry and intolerance, in that country, however, has taken a monstrous proportion. A minor girl in the north western part of the country was struck by a bigot's bullet because she had defied the edicts of the extremists of her

own faith against female education. Religiosity has adopted the mantle of monstrosity as people try to impose their own interpretation of religion on others by brute force.

The incidents of intolerance are not restricted to our own subcontinent alone. In Egypt, the fanatics raise their arms against fellow Egyptians for their Coptic faith time and again because they suspect the practitioners of this faith are conspiring against their religion. In Nigeria people of one faith attacked the prayer halls of another faith on suspicion that people of the latter faith were spreading western values and education, which they think will spoil the mind of the people of their faith.

It is a poor excuse to attribute these mindless acts of violence and religious intolerance to only righteous indignation of a community to insults to their religion or conspiracy of another faith against their own. The answers lie elsewhere.

A much deeper cause of such behavior and intolerance lies in the mindset of a majority of our populations that have been submerged in illiteracy, poverty, ignorance, and low esteem for self and community around them. Two thirds of the World's poor live in Muslim majority countries, where nearly half of world's illiterate also lives. The majority of the poor and illiterate mass lives in the Subcontinent, parts of the Middle East, and Sub-Saharan Africa where a high degree of youth unemployment, political volatility, and vulnerability to religious prejudices co-exist.

Poverty and ignorance have led people in most of these countries to put blames on others for their own failures, distrust of neighbors, and viewing any individual attempt to denigrate their faith as an international conspiracy to subjugate them. The ignorance is not just about other cultures and lack of awareness of other's rights, the ignorance is about one's own religion also. The consequence of the lack of true knowledge about one's own religion and its teachings is that people fall prey to manipulation by religious zealots, and political opportunists. No religion teaches violence; no religion teaches how to insult or denigrate other human beings, least of all the religion of the people of the countries we are talking about now. It is an irony that today the practitioners of one of the most tolerant religions of the world are identified with acts that are strongly denounced by their own religion. Yet all these acts of intolerance are perpetrated in the name of religion. People who wear religion in their sleeves need to remind themselves that freedom of religion is the cornerstone of their faith; it is the most fundamental teaching of their religion.

An important condition of freedom of religion is that it should respect the rights of others irrespective of their differences in belief and practices. Yet, the painful events in the countries that have come to lime light recently demonstrate that these rights continue to be trampled upon by either the majority community in these countries or by groups of individuals who want their thinking to dominate over others. To explain this behavior as errant or that of an extremist group is a poor excuse. There is something

more fundamentally wrong in such behavior than simply overzealousness of a group of people.

There is no easy way to get out of this morass, and eradicate the disease of intolerance and religious bigotry that exist in the world today. Bigotry exists in one form or another in every faith; but it seems that our share of this opprobrium is the largest given the examples that are often headlined in the press. Each nation and each country has to find its own way to deal with this scourge and get rid of it. The most important first step is to educate people in the rights of all human beings irrespective of faith to their beliefs, cultural and religious practices, respect and tolerance for all shades of opinion, strict adherence to freedom of religion and choices, and stern actions against any attempt to prevent any infringement by anyone of such rights. This education cannot be imparted by teachings in schools alone.

Religious tolerance and respect for all faiths is a part of one's belief system. This is a continuous education that has to be provided to all sections of the society through all media. The specter of religious intolerance has to be fought by building strong public opinion the leadership for which has to come from our political leaders, civil society leaders, and academics. This has to start from ground zero, from early child hood, and by examples not just precepts.

Islam, Islamist, and Islamophobia

The quirkiness with which world events change every day makes any forecast on future political outcome more difficult than predicting storm in fair weather. Only months ago when Ukraine and Russia were center of world attention and caused belly aches in Europe, everyone expected the crisis to explode and embrace at least part of Western Europe and its ally, the US, in a new battle. Sanctions from the west did not seem to bend the event to Ukraine's favor as the force behind the crisis appeared unmoved. But this is our world; events do not remain frozen in one stage. They shift, and shift quickly. The world stage was stolen by the new crisis in the Middle East where new actors seized attention resurrecting the world phobia of religious militancy and radicalism.

Islam has been in focus for some time in the past. It has been a frequent topic of discussion in the media in the west, particularly US after the most horrific events of September 2001. The discussion has not been always very favorable, but in the aftermath of the sad happenings of 2001 the discussion has helped to spread more awareness about the religion and its followers. And over the past years the followers of Islam also have come to appreciate more the need to educate others the true nature of their religion, and its message of compassion, humanism and tolerance. In a way the September 2001 became a water shed event also for the Muslims in the US to turn attention to them

and make them better understood by their neighbors and people of other faith. The diversity of faith and ethnicity along with the general atmosphere of mutual respect and acceptance of diversity in the country helped the Muslims in their effort. They found that they live in a country that is much safer, tolerant, progressive, and accommodating than the places they migrated from. They also found that equality and respect for humanity that their religion Islam preaches is actually more in practice here than the places they have left behind.

But Muslims in the US or other parts in the world do not live in islands. Events in Ukraine or Russia may not affect them in their identity as Muslims, but when other Muslims make claims in their name declaring war on others and adopt abhorrent practices in the name of religion, all Muslims are affected. They are affected because the great majority of them do not subscribe to these views neither do they want battles be called in the name of Islam. To the dismay of the great majority their religion seems to be hijacked by a group of fanatics who really want to establish a domain of their own to intimidate and terrorize innocent people. But a bigger concern for the Muslims is the label of Islamist that these radicals arrogated to themselves and the media acquiesced to it.

An Islamist, properly speaking, is a person who wants to lead his way life in the way his religion has prescribed. Viewed in this context it should not be different from a person who wants to lead his life in the way his religion

has prescribed, be it Judaism, Buddhism, or Christianity. Unfortunately, the current definition of the term is politically charged because many Muslims extend the term to a set of ideologies holding that "Islam should guide social and political as well as personal life".

There would have been little dispute if the ideology that Islam dictates was rooted to one interpretation of the Quran and teachings of Prophet Muhammad. The reality is that it is not so.

The Islamists can have varying interpretations on various Quranic verses, sayings of the Prophet, and his practices. They differ on whether the Quran allows judicious inferences, or exercise of intellect in interpreting the Quran. In one word, there is no consensus in the Muslim community as to how it shall govern itself. And hence many Muslims differ from the Islamist views that emphasize the implementation of Sharia (Islamic law); of pan-Islamic political unity; and of the selective removal of non-Muslim, particularly Western military, economic, political, social, or cultural influences in the Muslim world. The Islamic militants take this ideology to another level and want to fight all who in their eyes stand in the way of establishing this ideology. Their world view is a unilateral interpretation of the religion and imposition of the laws and practices that they think most appropriate. Hence their fight, and hence the war that the militants are waging seizing the opportunity that the civil war in Syria and a moribund Iraq has given them.

The most important reason why the so called Islamic State that the militants claimed to set up and has been able to hold up is the inability or unwillingness of the neighboring countries including Turkey and Iran to engage in this battle. In fact, bickering among Muslim nations on how to handle political Islam and the forces that promote the religious militants is the root cause of the spread of this armed movement. Absence of democratic practices and institutions in most Muslim countries and their abject failure to engage popular will in government have not helped much in stopping the growth of radical groups and their extreme philosophies in the Muslim world. The Islamic State is only a conglomeration of the radical groups and their radical acolytes spread across that region, with sympathizers from other parts of the world.

It is difficult to predict when and how this militancy will be stopped. The Air strikes that have begun have a limited capability. Even ground attack can have limited effect. The militants will move from place to place, seek new territories, and find other means to spread their mission. And we all know that these will be no peace missions.

The only effective way to stop this malignancy and prevent its growth is for the world Muslims to recognize that the state that extremists want to found is a threat to their religion, and urge that their governments meet this threat more earnestly and seriously. This includes allowing more democratic participation in the governance, and ensuring civil liberties and freedom of speech for all their citizens.

The threat of militancy and extremism in religion can only be stopped by allowing the population to have an open dialogue on what type of government they want, how a people want to lead their life, and what role religion should play in their lives. Rhetoric alone on Islam as a peaceful religion will not work; Islam will be better understood by its practice as a peaceful and tolerant religion. Unless Muslim countries and all Muslims of the world realize this, Islam phobia among non-Muslims will likely spread.

The Challenge of Religious Radicalism

In 2007 Maulana Fazlullah, leader of a Frontier based militant Islamic organization known as Tehreek-e-Nafaz-e-Shariat-e-Mohammadi (who later became the leader of Taliban-e-Pakistan) established a parallel government in about 59 villages of Swat Valley in Pakistan and introduced Sharia Law. This came not in one fell swoop, but after a long run in with Pakistan government and its feckless law enforcing agencies in that part of the country that began with US operations in Afghanistan in 2002. Maulana Fazlullah, also known as Radio Mullah because of his broadcast over clandestine radio in the Malakand Agency (where Swat valley is), began propagating Islamic jihad against Pakistan Government and its allies for establishment of Sharia Law in Pakistan. His ultimate success in driving out Pakistan government forces form Swat valley came after years of threats, both oral and real, to the people in the area who dared oppose him and his armed militants who continued to swell in number. He would be the supreme leader of the region for close to two years until Pakistan Army, mainly under pressure from the United States, which was worried that the rise of another militant group and its sway over the area close to Afghanistan would stymie its efforts to eradicate the Taliban from Afghanistan.

During Fazlullah's reign in the Swat Valley, he not only drove out the Pakistan law enforcement forces, but also civilian agencies and established his own laws that he

termed as "Sharia" inspired laws. Some of the draconian measures he took in the name of Sharia were closing of cinema halls, DVD shops, banning of music, and incredibly enough his supporters attacked barbershops for their "un-Islamic" practices (because barbers shaved beards). Sufi mystics and dancing girls were killed and dumped in the city square, and girls were not allowed to go to school. Fazlullah later issued Fatwa against Malala Yusufzai, the girl who bravely stood up girls' education, and had her shot by his supporters even after he had been ejected from Swat Valley.

Fazlullah's rise was enabled by a government that ignored the early signs of his group's growth in part, but largely because of indulgence of radicalism by succeeding governments of Pakistan by way of coddling of religious leaders, religious institutions in preference to progressive and liberal institutions, purely for short term political goals. The government of Ziaul Huq sowed the early seeds of radicalism through thousands of Madrassas that he helped grow ostensibly to feed the anti-Soviet war in Afghanistan. He and his successors used the products of these Madrassas later to form the Taliban group who would in future years topple Afghanistan government and rule there.

The break-up of the Taliban in 2002 by US intervention drove their leaders to the mountains including North West of Pakistan and lead to formation of a diverse group of religious militants in Pakistan, including that of Maulana Fazlullah. While the US was busy eradicating Afghanistan

of the Taliban, they and their ilk would find shelter in Pakistan, more precisely the Pakistan Army which had helped growth of the original Taliban in the first place.

Maulana Fazlullah and his armed militants thrived because Pakistan Government at that time was headed by a President (Asif Zardari of Pakistan People's Party) who was busier in defending his Presidency against political foes than defending his country from religious militants. His government was one of compromise, in particular with the powerful Pakistan Army, and he dared not take the Army to task for their seeming unwillingness to tackle the rising religious menace in Swat Valley.

The discussion on Fazlullah and his group is relevant for Bangladesh, not because there is such a figure on the horizon of Bangladesh, although there was such a threat some years ago posed by a militant in Northern Bangladesh. It is relevant because leadership for religious militancy and terrorism does not have to originate locally. The attraction that Islamic State or its affiliates have on youths inclined to similar views can come from anywhere. Their proliferation can also happen in many countries where youths are easily brainwashed or misled from parochial and illiberal education, biased interpretation of religion and its message, and paranoid ideas about the world where one is led to believe that their co-religionists are subject to a worldwide persecution. These ideas are further cemented in a country that has weak law enforcement, lack of personal security, and absence of good governance. In such societies

a section of youth can be easily deluded to believe that a strong government can only be enforced through religion and a religion based system. Anybody who opposes this is an enemy of religion and has to be eliminated.

There has been a string of murders in Dhaka and other places of Bangladesh in last two years. The victims were people from a cross section; some were writers, some publishers, some foreign nationals. Quite a few were from the minority section. There has been no arrest, let alone any conviction in these murders. What we have instead is speculation about the reasons for these murders from our political leaders and persons in authority. But more importantly we have assertions of responsibility for these murders (at least majority of them) from affiliates of radical Islamic groups that are rooted thousands of miles away from Bangladesh. But strangely these claims are refuted by our government leaders because admitting these assertions would be acknowledging presence of militant groups with foreign loyalty in our midst.

Rise of Fazlullah and his group in Pakistan and the menace they caused to Pakistan and continue to cause now was possible because of political exigencies. Bangladesh does not now have any known exigency of the kind Pakistan went through in the eighties and nineties that contributed to rise of religious radicalism in that country. What we have here are instances of some horrific murders that till now have remained unsolved but clandestine groups claiming loyalty to foreign inspired militant organizations have

reportedly owned responsibility for these crimes. There is no proof of these claims, but the apparent similarity of the victims (they were either bloggers of liberal thought, writers with secular reputation, or minority community members), should give hints to our law enforcing agencies that these murders are not random acts. These may be preplanned and the perpetrators could be organized militants waiting for an hour to strike.

I do not know when or if at all the perpetrators of these murders will be arraigned. But what I do know is that a first step to close the gap would be acknowledgment by our government that these murders are not necessarily shenanigans of political opposition to embarrass the government. To embarrass the government a political opposition has many other weapons in their arsenal other than killing bloggers, writers, and foreign nationals without any rhyme and reason. Let us start from the assumption that the murders could be the handiwork of a group of fanatics who want to establish their laws in the country by terrorizing people and anyone who opposes their belief.

An Islamist War in the Middle East

So this is finally happening. A band of militants fighting in the name of religion or jihadists as they call themselves has been able to quarter away parts of Syria and Iraq and has declared a new Islamic state after driving out a ragtag Iraqi army comprising mainly Shiite soldiers. The insurgents call their newly acquired chunk of land Islamic State of Levant because their dream goes beyond Syria and Iraq to other neighboring Muslim Arab countries. The leader of this ambitious group has grandiosely declared himself Khalifah (Caliph). For the first time since the map of this part of the world was redrawn by the West after the First World War, another attempt is being launched by militant Islamists to establish their world view on the map of the Middle East.

To say that this military success of the militants has taken the countries in the area or even the outside world by surprise would be a misstatement. It may be a surprise to the weakling government of Iraq but other countries in the neighborhood including Iran were all aware that the Islami jihadists had established firm foot hold in the area following the Iraq war and the beginning of the turbulence in the Middle East. The Syrian war gave birth to different militant groups fighting against the regime, but none more determined and aggressive than the Islamists who established their version of Islamic laws in the cities and towns they controlled.

The conundrum now is not how the jihadists have been able to drive away thousands of Iraqi forces from a large chunk of territory in Iraq and Syria, the main puzzle is how they have been to hold on to a territory bordering three countries (Syria, Iraq, and Iran) without much opposition. It seems the jihadists are now in comfortable control of the territory despite attempts at thwarting them with help of volunteer forces by the jittery Iraqi government of Malliki. Assistance from neighbors including Iran is scarcely visible, while the main ally of Iraq—the United States is in a watch and see mode. In the meantime the Iraqi army even with support from volunteers keeps retreating to the inner belt of the country.

There are two possible outcomes from this latest success of the Islamic militants. Either the map of the Middle East will be redrawn or this new breed of militants will be wiped out from the territory –at least for some years to come. Both cases will have serious repercussions in the Middle East with fallouts that may extend to the West as well.

The grand ambition of the militants to establish an Islamic Caliphate harking back to a period that spawned the Islamic world fourteen hundred years ago may sound quixotic to many. But to the strain of militants who swear by it is a dream that must be realized at any cost. This is a brand of Islamists who are different from others of their ilk including Al Qaeda that apparently disapproves of the harsh ideology and practices of the band. The group that vows to establish their ideals on the territory they have grabbed does not

believe in propagation of their ideas by word but by sword. They do not believe that a state is run by the will of people; they believe it is run by the will of God. They are not moved by the ideals of democracy, but by the ideals of theocracy. Democracy as is understood in the countries that practice it is anathema to the core belief of this brand.

An Islamic state based on the ideals of these firebrands will separate it completely from other Muslim countries in the area. And if the state does become viable, it will not stop there, because its grand ambition will be to convert all other countries to their definition of Islam and Islamic state. In other words the conflict will continue.

In an ideal world where no country interferes in the affairs of another, no community dabbles in the politics of another, in other words live harmoniously, a state could operate in any manner it liked so long it did not harm its neighbors. The so called Islamic State of Syria and Levant exists on name only in a territory that the militants have occupied by driving out the legitimate forces of the affected countries. It has yet to become operational, and if it did its viability would be open to question without acceptance from its neighbors and the international community. But it remains a possibility given the current conditions in Iraq and Syria. Without external assistance of a material kind to retake the lost territory from the militants, the possibility is looming larger every day.

The good news or bad news depending on the perspective one has on the issue is that a firebrand Islamic state bred by a dream of a medieval period will not happen simply on the tenacity or jihadi spirit of a militant group. The group may be aided with firepower and zeal of a band of committed radicals, but it will not succeed until it gets moral and physical support from people they want to establish their ideas upon. More importantly the territory they are holding on to will need more than their firepower to be viable. This will need either acquiescence or concurrence of the countries in the territory and the powers that sustain those countries. Militancy alone however imbued it may be with religious fervor cannot found a state.

New events close to the tri state area (Syria, Iraq, and Iran) with renewed hostility between Israel and Palestinians in Gaza have temporarily put the war in Iraq and Syria in the back burner. But with territories already lost to Iraq to the militants with possibilities of further inroad inside Iraq by them, parties vitally interested in the area will not remain dormant. An all-out effort to drive the militants and demolish them will be made by the countries threatened soon. A radical Islamic state based on the dreams of a band of zealots may not happen without external support and popular acceptance of the new rulers of the land people occupied by the jihadists. Unfortunately an outcome of either kind will be costly to all participants, most importantly to the people living in the affected areas. It seems the Middle East will continue to burn for the foreseeable time.

Fury of Militancy and Bloodbath in Pakistan

Once again Islamic militants in Pakistan struck an academic institution, this time a University near Peshawar killing 20 people. This violent incident follows a ghastly and more brutal attack by the same elements about a year back also in the same area that took lives of 141 innocent students. Ownership of both acts was claimed by the Pakistan Taliban, the group that has terrorized the North West of Pakistan for over a decade now, and has succeeded in petrifying the law enforcement agencies of Pakistan. One wonders if these barbarous acts continue to happen because the militants have become really invincible, or they are gaining strength through complicity of political forces now in play in Pakistan. Either way what the attacks on these educational institutions point at the message the militants want to convey to the authorities and rest of Pakistan population-- they will continue to harm these institutions and the people who attend them because they are not Islamic.

Only a few years ago the current leader of Pakistani Taliban Maulana Fazlullah (the person who had ordered the assassination of Malala Yusufzai) had seized control of Swat valley in the North West of Pakistan (his homeland) and established a so-called Islamic form of government there. Fazlullah had been best known as the fiery and charismatic "Mullah Radio" for the pirate radio station he operated in Pakistan's Swat Valley from 2004. Initially the

Pakistan Government had ignored the rise of Fazlullah, but he took the Government's indifference as encouragement and turned his religious mission into a military campaign. In December 2008, his followers seized control of the Swat Valley and began imposing their own brand of "Islamic justice". He punished barbers who had trimmed beards along with shopkeepers who sold music cassettes and medical workers who offered polio vaccinations. Schools that taught girls were attacked and policemen and opponents were murdered. This is why he ordered assassination of Malala who had protested shutting down of girl's schools.

Maulana Fazlullah was tolerated by Pakistan Army because he had not yet joined Tehrik-e-Taliban of Pakistan, a force that Pakistan Army was fighting. It had hoped (with backing from the US), that Fazlullah could be used against Pakistan Taliban, But the tables were turned when Fazlullah became the new leader of Pakistan Taliban after the death of Hekmatullah Meshud, the leader who had succeeded the ferocious Baitullah Meshud. In 2009 Pakistan Army finally launched a massive strike against Fazlullah and regained control over Swat but not before significant losses on both sides. Fazlullah and his men were believed to have escaped to inaccessible areas along the tribal belt bordering Afghanistan. He would launch his militant attacks, covert and overt, from various places without getting caught. (It was wrongly reported that he was killed in a Drone attack in March 2015).

The story of exploitation and control of religious elements in Pakistan date as far back as the General Ayub Khan, but this was perfected by General Ziaul Huq who is believed to be the facilitator of extremist politics in Pakistan. He was the prime mover in founding and funding the Mujahids of Afghanistan, a motely force of religious radicals drawn from various parts of Pakistan, Central Asia, and Middle East (albeit with US and Saudi resources). He generously channeled funds to create thousands of religious schools across the Afghanistan border to create hordes of radicals who fought the Russians. These radical products who the madrassas continued to churn even after the departure of the Russians formed the core Taliban that Pakistan Intelligence created to topple the later Afghan government.

It is no surprise that the Pakistan Army would later use similar ruse to patronize one militant brand to contain another militant brand. The original Taliban was the handiwork of Pakistan Intelligence, and its later division into Afghanistan Taliban and Pakistan Taliban is also their brain child. Lost in this game of power and control is the lives of thousands of innocent people and the future of a country that has not been able to get rid of the tentacles of a powerful army that has virtually ruled the country for much of its existence.

Today militancy in the name of Islam is a global phenomenon. Unfortunately, the victims of this militancy are not only non-Muslims but also Muslims. In fact, the Muslims far outnumber nun-Muslims. For every one

non-Muslim target, there are ten Muslims. When Islamic militant strikes, he does not distinguish between non-Muslims and Muslims, he strikes because he is against anyone and everyone who is in his way. To these militants all secular establishments are an anathema, all western education is forbidden, and modern science and education are taboo because they smack of western origin. Sadly, in Pakistan despite presence of many progressive elements and achievement of many of their scholars in western science and education, the overwhelming mixture of politics and religion, and patronage of religious dogmatism from the top have led to the rise of religious radicalism and extremism in the country. The voice of the progressive and moderate elements (as in some other Muslim countries) is suppressed because the country's governance is not in their hands. The bloodbaths in the academic institutions of Pakistan and loss of innocent lives will continue to happen unless politics is redirected in the country through a change in actual control, from the unelected power to real representative s of people.

Collaterals of Terrorism

The recent acts of terrorism in several parts of the Globe shook the world, but the victims of the terror acts were not confined in the cities where these happened. The direct victims may be those who died in these sordid actions, but the other collateral victims are from the community to which the perpetrators apparently belonged.

Muslims all over the globe, at least the overwhelming majority, were obviously shocked and ashamed that people from their faith could launch such cold-blooded acts of terror on innocent people. But they have been shocked before several times by similar incidents of terror that were unleashed on innocent people in various parts of the world including Muslim majority countries. And like before they are the ones who have to bear with the backlash of these events.

Terrorism is not a new phenomenon, it has happened many times in the past all over the world. The most common kind of terrorism is by an organized group fighting for independence or to advance a cause such as by the Maoists in the subcontinent, Basque nationalists in Spain, Sean Fein in Ireland, etc. The other type is lone wolf acts where the individuals have gone on mass shooting of people because they have personal grievances against their government or simply they snapped out. In US 934 people died in last seven years from mass shooting by individuals. Significant among these incidents were killing of 32 people by a

student in Virginia Technical Institute in 2011, killing of 26 elementary school students and teachers in New Hampshire the same year by a single gunman, shooting by an individual in Navy Yard, Washington DC in 2013 killing 12 people, and the killing of a dozen people in a college campus in Oregon in 2015. In 2011 two sequential loan wolf attacks killed a total of 77 people.

What is the difference between these attacks that are nothing but acts of terrorism and those we have watched recently in Europe or elsewhere? Why the perpetrators of these attacks are not identified by their religious persuasion or ethnic identity? Why the causes for these acts, at least most of them, are attributed to deranged state of mind of the executors and their sociopathy and no other association is investigated? Do the horrific acts of these individuals make their families and neighbors guilty by association?

Dalia Mogahed, co-author of the book "Who Speaks for Islam?" recently echoed some of these thoughts in a TV interview recently. She said, "When you look at the majority of terrorist attacks in the United States according to the FBI, these …. attacks are actually committed by white male Christians. When those things occur, we don't suspect other people would share their faith and ethnicity of condoning. We assume that these things outrage them just as much as they do anyone else. And you have to afford that same assumption of innocence to Muslims."

These are some questions that the recent of tragic happening in Paris and those before raise in some mind. Why are the adherents of the faith to which the lone wolf terrorist belong be viewed differently?

A simple answer would be that in lone wolf acts of terrorism now or politically sponsored terror events of the past, the executors did not carry out their acts to uphold a religious mission or objective. The lone wolf terrorists or mass shooters in US or Norway were not claimed by any radical religious group and hailed as heroes or martyrs by any radical group.

The terrorism that we are now facing is posed by a highly committed group of people who are determined to bring about changes based on their idea of religion and its laws. These changes they seek are first for their religionists, and later for others. They do not care if their actions turn their co-religionists into collaterals. In fact, it is a part of the strategy of this radical group.

The terror acts of France, and more recently Mali, have turned attention of all countries, particularly the west not only on the terror groups and their affiliates but also on the Muslims. In many countries the Muslims now find themselves not only defending their faith but also themselves. They find themselves as suspects in the country of their adoption which they love and are loyal to. Two Republican Party Presidential candidates in US have gone on record to demand that all Muslims in the US be subjected to some

kind of surveillance. Some members of the Congress and several State Governors have demanded that refugees from certain parts of the Middle East, mainly Muslims be not admitted to the US. These may be rhetoric in an election season, but the words uttered by them do not speak of a benign view of the Muslims only because some terrorists are using Islam as their main driver.

The suspicion and hatred that the Muslims face cannot be removed by condemnation of the terror acts and dissociation from these acts by calling them as un-Islamic. It will not be achieved by simply defeating the militant groups. The real action is by reforming thoughts and convincing others around about real Islam.

The phenomenon that we are watching today is because most Muslim countries and Muslim leaders failed to provide a broad-based education to their people that not only exposed them to correct interpretation of their religion but also taught them values of human rights, diversity of opinions, and equality of human beings. Our leaders will do well if they inculcate these teachings in their people and ask them to turn to the future instead of harking back thousand years ago for inspiration. Otherwise our youths will continue to be attracted to the false prophets who are darkening the horizon and lead them to many more disasters direct and indirect.

The writer is a political commentator and analyst.

Bloodshed in Brussels and Angst of Muslims of the West

The terrorists struck again within six months of the carnage in Paris, this time in Brussels, the city that serves as headquarters of both NATO and European Union. Brussels is not unknown to terrorism, the city saw acts of terrors no less than six times in past few years, but none with the ferocity and violence of March 22 that demolished part of an international airport, a subway station, and took at least 31 lives. The number of deaths is the highest so far from terrorist attack in a single day in a European city. As in the past such occurrences in Europe the viciously militaristic outfit of ISIS came out boldly declaiming ownership of the horrendous attack.

While governments in Belgium, France, USA and UK condemned the attack and swore to strike at ISIS and end its cycle of violence, the entity continued to thrive and attract militants who are either directly employed by the organization to carry out terrorist attacks or are inspired by the organization's message to attack countries that are deemed to be its foes. The most fearful and daunting aspects of such attacks are that these have been launched by militants who are mostly homegrown. All seven of the attackers in Paris in November were either French or Belgian citizens. The three identified as the bombers of Brussels attack are reported to be Belgians. But more importantly all of these attackers are also Muslims descended from

immigrants from Morocco or Algeria. And that is the crux of the problem and cause of angst of the Muslims. Not only in Belgium, France, and UK and other parts of Europe, but also as far as the United States.

Immediately following the Paris attack, the neighborhoods that were targeted for search and surveillance were those mostly inhabited by Muslims. Despite protestations by French President and politicians that Muslims need not fear a counter attack, the Muslims of France felt vulnerable to condemnation by general public because the attackers were fellow Muslims. Although no visible discrimination was made against Muslims but they felt insecure as Police scoured Muslims neighborhoods and raided apartments in search of suspects.

The latest apprehension of a Paris attacker, Salah Abdeslam, from a mostly Muslim neighborhood of Molenbeek in Brussels lent further fear among Muslims that any neighborhood inhabited by Muslims could be easy target for search. What is more fearful for the Muslims is how such new attacks feed the apprehension of non-Muslims against Muslims in general and make their normal living more difficult in those countries. In the ongoing campaign for Presidential nomination in the US the candidates have made war against terrorism a central issue, and are projecting each as the best to beat ISIS. But in running that campaign against terrorism two Republican candidates, Donald Trump and Ted Cruz are vilifying just not the ISIS, but also Muslims. In the heels of Brussels attack Ted Cruz

declared that he will support policing and surveillance of Muslim neighborhoods in the US.

Terrorism is not a newly found phenomenon in the World. It has been the chosen of path of many organizations and political parties in the past to claim freedom or overcome oppression. Terrorism was not identified with one particular political belief or religious entity. But unfortunately in the past decade it has generally come to be identified with Islamic radicalism because the activists who carried out acts of militancy did so in the name of Islam. While the majority of the Muslims in the west either denounced these acts or distanced themselves from such groups, the Muslim communities were not proactive enough to counter these forces that secretly grew inside.

Radicalism does not grow in a vacuum. Either it comes out of a feeling of neglect, frustration, and desperation, or from being brainwashed by an ideology. In the case of radicalized youths of UK it has been suggested that a large number of them turned this way because they felt they were marginalized or unassimilated in a society that gave it no promise of growth. In the case of the militants in Belgium and France who were apparently born in those countries their radicalization came not from deep religious faiths or ideology, but from societal neglect, poverty, and early association with crime and criminals. All reportedly had criminal records before they bonded with ISIS which gave them the wherewithal and required training for

militant operation. They were easy cannon fodders for the malevolent organization with grandiose schemes.

Unfortunately, elements like the Brussels and Paris attackers cannot be stopped by hitting at ISIS territory alone. The biggest conundrum of fighting the militant outfit of ISIS is determining whether the fighters working for the entity are limited to the geographic territory it has currently occupied, or it has volunteers and loyalists who have penetrated more countries extending far beyond its known territory. It is important because a war that targets only the territory that it currently occupies may dislodge them from it, but not its loyalists or volunteers who have spread out. Similarly elimination of a single leader may not bring an end to the whole organizational structure. The entity as a whole may rotate leadership, just as it may move its physical location from one country to another.

To make a war against terrorism a success the efforts will have to be made in each country affected by it or likely to be affected starting with its minorities, Muslims in particular. Assimilation is not a one way exercise. The community leaders have to make an effort to make themselves, their culture and religion better understood in schools, community places, and by participation in local activities including local elections and political parties. The more the Muslims spread themselves out among the larger communities less anxiety they will create in the mainstream and less material they will provide for fear mongering among bigoted politicians.

Orlando Massacre

The bloodbath in Orlando, Florida, on June 16 (2016) is a grim reminder that terrorism and terrorists will spawn anywhere, anytime. Acts of terrorism do not necessarily follow a predictable pattern or norm. The attacker in Orlando was of foreign descent, but he was born and bred in the USA, went through school not far from where he perpetrated his mayhem, and ostensibly led the humdrum life of an average employee working as a security guard (an irony in itself!). He had a wife and a small kid (he was briefly married to another woman before, but that is normal in this country), and his parents—immigrants from Afghanistan—lived in the same city. His neighbors or coworkers never suspected that a monster lived in him.

There have been several mass killings in the USA in last five years. In 2012 a gunman shot and killed 20 first graders and six adults in an Elementary School in Connecticut. The shooter later killed himself at the scene. In 2013 a Navy contractor and former Navy enlisted man, shot and killed 12 people and engaged police in a running firefight through the sprawling Washington Navy Yard. He was shot and killed by police. In 2014 a killer in Isla Vista, California, meticulously planned his deadly attack spending thousands of dollars in order to arm and train himself to kill as many people as possible. Later he killed six people before shooting himself. In June 2015 a teenager in South Carolina entered a church armed with an assault

rifle and mowed to death nine people. Same year in October a student in a community college in Oregon shot to death eight fellow students and a teacher. In November that year an anti-abortion activist attacked an abortion clinic in Colorado and shot to death three people in that clinic. But the deadliest killing happened in December 2015 when a couple descended in an office building in San Bernardino, California armed with bombs and firearms and slaughtered fourteen people who were co-workers of one of the killers. The couple was later chased and killed by police when they engaged in fight with police.

The account above does not include many other smaller occurrences of mindless killing in last five years or the years before. The important fact is that murders by a single individual at a single site are not unknown in this country. US history, particularly of last twelve years or so, is replete with such incidents of slaughter and murder of innocent people; by individuals whose motives have not been always clear to people or the investigators.

What stands out between other cases of mass killing and the one in Orlando or San Bernardino is the religious identity of the killer or attacker. In both cases the attackers were Muslim. In San Bernardino case the male attacker, a US born individual of foreign extraction, was later claimed by the investigators as radicalized Islamist who had been secretly commiserating with ISIS. In case of Orlando calamity, the attacker, also a US born man of Afghan descent, is claimed to have declared his allegiance to ISIS prior to that attack.

Question may be asked why the religious identity of the killers in Orlando and San Bernardino was brought into limelight while this subject was not mentioned in other cases of mass shooters, and this may merit all together a separate discussion. But at a time when ISIS has become a dread of the Western Countries (including many Muslim countries), and homegrown terrorism has become commonplace, it is not unusual to associate a terrorist with that dreaded force, particularly if he or she is Muslim extraction. The investigators start from this hypothesis and would like to conclude that way unless proved otherwise incontrovertibly.

For Muslims in the US the Orlando tragedy is a double whammy. For one, it again brings into public eye their religion and coreligionists in a negative way, and focuses on the proneness of their youths to radical thoughts and actions. On the other, it sharpens the current Presidential election campaign where a rabble rousing candidate like Donald Trump can gain traction for his campaign rhetoric against Muslims and other minorities by stoking more fear of people citing these acts of terrorism.

No words can denounce enough any act of terrorism, least of all the kind that wiped away forty nine young lives in a matter of hours in Orlando. As President Obama said of this incident that it does not matter by what name you call it (radicalism or terrorism), it is a horrific and grossly inhuman act that no religion, race, or orientation can tolerate.

Muslims in USA and all over have condemned this horrible occurrence as they have denounced similar others in the past. But denouncement apart they also have to recognize the reasons why their community comes into focus when the perpetrator happens to be one of them. One reason is the frequency with which terrorist acts happen both in Muslim world and elsewhere in the name of their religion, and the other, the perpetrator blithely boasts of committing these heinous acts for his belief.

It is ironic that in majority cases of such terror acts in the name of Islam, be it in Europe or USA, the perpetrators are hardly devout Muslims or pious people. They are either mercenary or psychopaths who have their own motivation to commit these acts. In majority of the lone wolf cases the perpetrators are of the same psychological frame as those countless others who slaughtered people in Connecticut, South Carolina, or Washington DC. The latter perpetrators were not tagged to any religion or belief because they did not say so.

It may be relatively easy to wage a war against a known group of war mongering terrorists such as ISIS or Al Qaeda, but it will not be easy to weed out sick individuals who fall prey to their own delusional ideas and take cover under a belief. It will take a whole community to keep this vigil to spot and stop such individuals. We hope we can all wake up.

Cannon fodders of the terrorists

A principal objective of terrorists is to immobilize a population and their targets by the suddenness of their actions. A stealth attack in public areas with bomb or firearms, random killing, arson or random vandalism on public property. The actions are preplanned but the places or targets are chosen at random. These are hallmarks of people who want to stage an insurrection or destabilize societies or governments they are fighting against. The irony of these insurrectionist attacks is that while the strategy or the grand plan is designed by the leaders of these movements, the foot soldiers of these attacks are people who are recruited either through false ideology or money. In either case the recruits tend to be malleable young people who have either grown up in societies of great inequality, or with great economic adversity. There may be some who are drawn by misguided political philosophies, but these tend to be more recruiters than recruits.

Currently two separate battles are being fought in two different parts of the world. One in some European countries, and the other in Bangladesh. One may raise one's eyebrows at this odd parallel. But when you look deeper you will find the similarities.

The battle in the streets of Europe is being waged against terrorists by law enforcing agencies. These terrorists are not foreign agents or foreign implants, but are home grown albeit not from the mainstream ethnic group of

these countries. But nevertheless they are citizens of those countries who seem to have resorted to extreme means to vent their outrage against their own government in a most violent manner. These countries are highly democratic with democratic institutions that date back over a hundred years. But unfortunately the groups that carry out these acts would not consider them to be part of these institutions and they carry out their violent acts to vent their feelings instead of choosing a more civilized way to do so.

In Bangladesh we had an opposition that chose to sit out of parliament and elect the streets to express their outrage for an entire five-year period. This was followed by an unsuccessful boycott of the next elections later but not before countless street battles, deaths, and severe damage to the economy. One would expect that unlike the fringe groups of Belgium, France, and other parts of Europe who have a tremendous feeling of non-assimilation and neglect, in Bangladesh no such groups would exist that have a tremendous dislike for the country and its people. Otherwise how do you explain mindless attacks on children and women, uprooting of railway lines, burning of public transports, and total mayhem in the name of enforcing strikes? How do you explain blitzkrieg like attacks on people, property and law enforcers which are in no way different from the terrorist attacks in Europe?

The similarities do not end here. In both parts of the world people who are in the front line laying down their lives are not the leaders who have recruited them, but the

ones who have been recruited. In European countries the recruits may have been brainwashed by misguided and misinterpreted ideology; in Bangladesh they have been mostly recruited through money. In both cases the leaders are safely managing the battles from their secure forts of money and influence.

There are more similarities between the two news making events. The recruits in Europe have several things in common. They are mostly young, children of immigrants who were raised in impoverished ethnic neighborhoods with little skills fit for gainful employment. They were drawn to extremism by radical preachers who probably inspired them to vent their outrages in ways that would destabilize the society for the long term goals of these false ideologues. The anarchists in Bangladesh have mostly one thing in common; they are poor, unemployed, and are available for hire to anybody who would pay them any money. These are not trained terrorists in the sense their European counterparts are. They are mercenary who play to the tune the political pipers play. However, the one unifying factor of these recruits in both battle grounds is that they are the ones who are most likely to lose their lives in the first place, not their recruiters.

There is no difference between political terrorism and religious terrorism. It is simply intimidation of people to deprive them of their right to move, speak, or practice their beliefs openly. In mature societies rule of law prevails because people respect law and each other's rights. Sadly

it is not so in countries, which have yet to show respect for each other let alone for law. Europe will be ultimately able to contain the temporary disruptions in their societies because they have transparent and democratic governance in place. Regrettably we cannot be that confident about Bangladesh. Our political leaders use people as pawns and hold them hostage by outsourcing their loathsome acts to delinquents who are willing to be used. Good governance, accountability and responsibility are not in their vocabulary. That is why the fights will continue with temporary respites now and then, and the cannon fodders will continue to lay down their lives because the pied pipers of politics will continue to play heir tunes.

Carnage in Paris- the beginning of Apocalypse?

Once again we are face to face with another bloodbath, senseless and brutal killing of innocent people in Paris by a robotic gang that is recruited and operated by a group of malignant people with a twisted ideology. This is an ideology that has no semblance to the religion they claim to proclaim, nor does it have any precedence in its fourteen hundred years of history. The only resemblance it has is with the ruthless massacres of the middle age by Mongol hordes or individuals hunted by Spanish inquisitors for their alleged blasphemies. It is an ideology of a sick mind that wants to use religion to gain power and subdue people through oppression and fear.

The Paris massacre has once again brought to light the visceral spread of extremism in more vulnerable sections of population in otherwise affluent nations either through alienation or attraction of radical ideas spread by the zealots. The suspects of Paris killings have not all been identified yet (seven were killed), but it has been suggested that at least three were local, which leads to the issue of home grown extremism and its causes.

European cities including London had seen many incidents of terror over last fifty years. In early years these incidents were carried out by a motley group of terror organizations, some with nationalist aspirations such as IRA in UK, Basque Nationalists in Spain, or even criminal organizations in Italy. With time the perpetrators became

associated with militants espousing Palestinian cause who were mostly drawn from foreign bases. The terror attacks and militancy in the street gradually took a more local color in 2005 when some 50 people died from bomb attacks in London buses and trains by terrorists who were identified as young radicalized Muslims. European cities since had been targets of attacks by terrorists claiming affiliation to one or another of Islamic militant organizations, but all of these pale to insignificance compared with the horrific event of November 13. On a global scale so many deaths from a terror attack on a single day this will be one of the gravest ever.

What will follow next is the unfurling of consequences and Western response from this attack. France has already reacted to the Paris carnage even as its people as well as the rest of the world are reeling from the shock. It has bombed the headquarters of the so called Islamic State (ISIS) who boldly declared ownership of the attack. A more intensified attack on ISIS coordinated with other countries will likely follow. But there are graver consequences for the region as a whole, and the immigrants from these countries will likely follow soon.

The event in Paris may be ISIS sponsored and it may even have foreign collaborators. But the fact that there have been more than one terrorist among the perpetrators who are French citizens can have grave consequences for the country's Muslim minority. As it is, in previous terrorist attacks the suspects were identified as radicalized

Muslim youths. This is a subject that will not sit well with many people in the country and it may lead to pressures on the government for stricter surveillance of its Muslim population to the chagrin and further alienation of the minority group. The second and the most immediate effect will be on the thousands of refugees from Syria and other parts of the Middle East now knocking on the doors of European countries including France. With some of the Paris attackers suspected to be of Syrian or Egyptian origin, pressures will now be mounted on European governments to think twice before allowing shelter to the refugees from the Middle East.

Consequences apart, there are also some inescapable inferences from this coldblooded act and claims of responsibility for the act by ISIS. First is the outreach of the militant organization beyond its borders to not only lure volunteers to fight its war in Iraq and Syria, but also to carry out terror acts in territories far beyond its lair through local recruits. The Paris attacks may have had foreign participants, but evidences suggest that these were facilitated and coordinated by locals who would gladly give their lives to perpetrate the acts for a higher goal. Second is the ascendancy of ISIS over other radical Islamic groups such as Al Qaeda, Al Shabab, Boko Haram, etc. who had been ruling the militancy scene in the Middle East and other parts of Muslim world so long. This largely comes from the ability of ISIS to seize and retain a sizeable geographic territory and have an army of its own, and partly from the fog of a rigid Islamic government and society that it has

created around it. Their survival despite combined efforts by the Western powers including Russia to dismantle it has emboldened its loyalists as well as sympathizers. The number of such loyalists and sympathizers may continue to grow unless the powers fighting the militants can prove the vulnerability of the organization and hollowness of its appeal.

It is possible that a fierce response to the new militants in Syria and Iraq will stymie them and even dislodge them from their base, but it will be a long time before the thought and ideology they are preaching will be eradicated all together. The crisis that European countries face is an internal one that has to deal with the mindset of its Muslim minorities on their place in society. They will to continue to remain responsive to rebellion and violence unless they are assimilated in the larger society in a way that is cognizant of their separate but equal existence. This will mean teaching and practice of tolerance by leaders of the minority groups instead of hate and distorted view of their religion.

Drawing a Line in the Sand

I write in deep anguish, in deep resentment, and somewhat in despair over the happenings of this week. These happenings were blatant, in your face insults to our nationhood, to the core values of our struggle for independence. On the surface these affronts were a reaction of a bigoted minority to the historic upsurge of national ire against war criminals, and justice demanded by our youths against the criminals that was voiced over three weeks in Shahbagh Square. But deep down this is a resurgence and muscle flexing by elements that have inherited the spirit and philosophy of the forces that stood against us, and aided and collaborated with the power that had launched the war against us in 1971.

In 1971 when the Pakistan Army was in a full scale war against the civilians of Bangladesh, a cadre of people from among us formed bodies to aid the marauding army in their murderous tasks across the country. Their motivation was religion, and not ethnicity, language or culture that defined us a Bengali nation. In the name of religion this cadre would perpetrate heinous crimes against their own people, and they rationalized their acts against humanity in that name. As a sub-divisional officer in a district of Dhaka that period I had painfully witnessed how a leader of that cadre would purvey to the dictates of a Pakistani Army commander who was the local Martial Law Administrator. He was a lawyer by profession, but newly anointed as Chairman of the Sub-divisional Peace Committee. In that capacity he

would spy on all neighborhoods and local officials, report to the Army Commander on concocted anti-state activities, and help army raid on local villages. In a desperate act I was able to nab this man on some criminal charges, but none stuck until after liberation. After independence the man was arrested and I was asked to depose against him (although by that time I was no longer in charge of the sub-division). As I was leaving the court after deposition the man smiled at me from the dock and said my deposition would not hold, and that he would be soon free. I never knew if he was sentenced to jail, but I do know that many like him moved about freely without ever having to pay for their misdeeds.

Last week's happenings make me feel that this is 1971 all over again. We are faced with the same ideological divide that launched us into our fight for independence. We are facing the acolytes of the same belief that wanted to deny us our nationhood on the basis of our language and ethnicity and fought against us from within. We are again witnessing resurgence of a force that had never come to terms with our right to exist as a country that put our culture, language, and ethnicity ahead of anything else. We are again thrown back to the time when this force worked with our enemies to put an end to our struggle for independence by liquidation of our people in the darkness of night, all in the name of preserving a country that was built on a deeply flawed ideology. Again we have a line drawn in the sand by our adversaries. And maybe this is a good thing that this is happening now.

Perhaps this new drawing of the line in the sand so soon would not have happened had there been no Shahbagh Square uprising. Perhaps we would have allowed this cancer to grow unnoticed and we would have gone about merrily with our politics as usual. But just as the whole Shahbagh Square movement took the nation and our political parties by a storm, the fallouts of this movement also shook the nation to no end.

While the biggest outcome of the movement is the reaffirmation of our faith and firm adherence to the core ideals of our war of liberation and a renewed rejection of those who opposed those ideals, another major outcome is the demonstration of people's will to reject politics that uses religion as a platform. This post liberation generation has shown that they no longer carry the baggage of the flawed ideology that once built a country based on religious affinity ignoring ethnicity, language and culture. The upsurge showed that in politics what figured most was honesty and integrity, and adherence to the values of our independence, respect to our ethnicity, culture, and keeping religion separate from politics. However a parallel by-product of this movement has also been aggravation of the negative forces that have always been acting in the opposite direction. For these forces 1971 war never ended. For these forces the ideology on which Bangladesh was founded is an anathema. The forces lay dormant for a time, but they would rise when circumstances were in their favor. In times of crisis they retreat, but they regroup and reenergize when

the crisis moves away. When they come back they attack with greater force and intensity.

It seems from the events of past few days that the evil forces are flexing their muscles once again to take away the hard earned gains of our freedom. This is at a time when the majority in Bangladesh have unequivocally sworn their adherence to pursuing their dreams of a democratic society based on respect for all religions and of all humanity at large. This is at a time when this majority has unequivocally spurned religion based politics and its followers, particularly those who had opposed our war of independence and had carried out murderous attacks.

The voices raised at Shahbagh Square demanded justice for an aggrieved nation for crimes that were committed against people during our war of liberation. Unfortunately the people who we have in the dock today are a handful from among hundreds or perhaps thousands of such people who fought us on a false ideology. Maybe we can get some justice by prosecuting those we have at hand. But what do we do about the ideologues and acolytes of this ideology who are now threatening our identity as a nation, which we are trying to build based on our core values of independence. The Shahbagh protesters may constantly remind us of these values, but how do we contain the counter values that the new-fundamentalists pose or threaten?

The enemies of our freedom struggle were not all foisted on our soil from outside. A good number came from within

us, and they continue to live among us. They take the garb of religion to fight us and delude our innocent masses for their own political objectives. A ban on the activities of a political party based on its affiliation to religion may be a short term solution, but it will not be effective to alter a mind set in the long run. For this we need a more conscious and deliberate approach to educate the whole society to take pride in our identity first as a Bengali nation, on our culture, language and ethnicity. We need to constantly educate our next generation on this identity first, and remind them that religion and politics are separate. We need to educate them that we need religion in our personal lives and not in state politics. And that is the true drawing of line is the sands.

From Arab Spring to Arab Winter: Future of Democracy in Muslim Countries

Four years ago the democratic world, particularly the West, was enthralled by the wave of popular uprisings in the Middle East that swept away decades of strangleholds by autocratic regimes in that region. From Tunisia where it started after self-immolation by a shop keeper, the wave of democratic uprising swept all through Egypt, Libya, Syria, and even closer to Saudi land, Bahrain. The series of protests and popular upheaval removed dictatorial regimes in three countries, and brought another regime in Syria to its knees. While the movement shook up the entire Middle East, it also brought hopes of a change for the people in that region, a change for a better government that represented people's wish.

The jury is still out to decide if the popular uprisings of 2011-12 and end of the dictators in three countries brought the change that was hoped or they made any visible changes in the lives of the people there. In Egypt, the military is back after a popularly elected government was dethroned for trumped up charges of corruption and the military is back in the reins albeit through an election. In Libya the country is segmented in two halves-one in the hand of a so-called elected government while the other half is in the hands of Islamic militants. Syria uprising morphed into a hydra-headed monster, giving birth to a group of radical Islamists who by far have proved to be most lethal in its dealings

with their opponents, and far more committed to establish their vision of an Islamic state than any other radical religious groups. Yemen, where the uprising was mainly on a partisan basis between the ruling Sunni President and his Shia opponents, there was a temporary truce with the incumbent President resigning. But instead of ushering the country into any democratically meaningful change the country broke into sectarian wars which have now drawn the country's more powerful neighbor Saudi Arabia into the fray. It is only Tunisia, which literally started the fire, has been able to weather these counter attacks and is still able to hold out with a democratically elected government, albeit is tenuously holding on deflecting continuous attacks by militants on the population.

There are many reasons why the promise of 2011 for democracy and democratic governments in these countries did not pan out. Although each country has its unique political condition and sectarian structure to account for the subsequent events, a major reason for the failure is absence of political leadership and political institutions that nurture and uphold democracy in these countries. Years of autocratic rule and dominance of politics by army in many countries ensured that no political institution that promotes people's rights and universal franchise exist. In Egypt, political leadership outside of the ruling elite was confined within the religious groups and other minor parties that mainly depended on the government for participation in the charade of Presidential elections that the country used to have for decades. The only true opposition, the Muslim

Brotherhood was banned, and even after the overthrow of Hosni Mubarak, the party had to reconfigure itself in a different name.

In Libya, politics was determined by Muammar Gaddafi, who ruled the country through Revolutionary Council and Revolutionary Committees. Individual political entities apart from Gaddafi's own committees did not exist. In Syria up until 2012, the constitution created a one-party state, the Baath party, which was vested with powers to run the government. The uprising of 2012 led President Assad to amend the constitution to allow multi-party system, but the elections to the parliament were manipulated to return the Baath party to power again.

Of all the countries, Egypt had the biggest promise of ushering reforms that would have impact on all neighboring countries. Tahrir square became a symbol of resistance to all autocratic and anti-democratic forces, and a beacon of hope for establishing human rights. Fall of Hosni Mubarak had a domino effect on the neighboring countries. But unlike Libya where Gaddafi faced a cruel end, Hosni had a more decent exit; he resigned, although to be incarcerated later.

Unfortunately the hope of democracy and rule of people that the fall of Hosni Mubarak could not be sustained. A popular election that put a coalition of Muslim Brotherhood and allies in charge would soon find itself facing another upheaval against it because the opponents of the alliance

were unhappy. This second uprising in less than two years would be used as an excuse by the all-powerful Army to step in and throw out the elected government and put its leader in Jail. Egypt today is again run by an Army General as President, albeit elected under a heavily controlled election.

Libya was also hypothetically liberated after the death of Gaddafi leading to a hope for a popular government that would be elected by people. But that dream would disappear when the elections that led to formation of a government would be rejected by the opponent, and the country would be launched into another civil war. The country is practically is divided into two parts, one occupied by a force claiming Islamic caliphate, the other the remains of a so called democratically elected government.

Syria is a completely different story. The early hopes of an end to dictatorial regime were dashed to the ground because of internecine war among the dissidents and later rise of the force that menaces the entire region with their draconian form of militant Islam.

Western democracy as it exists, either in parliamentary or Presidential form is based on the fundamental principles of universal human rights to free speech, free movement, quality, and rule of law. Unfortunately, few of the Muslim countries experienced democracy in its essence. With wars ravaging the Middle East and most Muslim countries in a state of conflict of one kind or another, it is inconceivable that democracy as people in the west understand will ever

be established in any of them. A customized democracy such as in Malaysia and Indonesia may be an answer for some countries, but even this will require a bold leadership that puts rights of people above everything else, including religion. Otherwise, the Muslim countries will continue to battle the demons among them who want to destroy every aspect of human values including democracy to establish their mistaken interpretation of religion and terrible ideology.

In the Name of God and Religion

The south eastern part of Bangladesh is aflame again with outrageous attacks on the local minorities for some alleged insult by a member of that community on the majority community's religious faith. Only recently, the world witnessed a massive venting of anger and rage by Muslims in many countries to protest a wanton and inflammatory film on our prophet. Although the alleged film maker acted on his own, much like a few people before him who had tried to deride a person deeply revered by people of all religion, the anger and outburst of the Muslims were unfortunately targeted at the country where the film was made. Such was the anger that it took the lives of an ambassador and three of his colleagues in one country, set buildings on fire, and destroyed property worth millions in other countries. So blind was the anger that seized the mobs in these countries that it never occurred to them that in their fury what they were destroying belonged to their own countries, and their own people. Fire that they lit not only burnt a foreign flag but also everything that came within the reach of that fire.

Insults to a particular faith and its practitioners are not new. This has happened many times in the past because there are bigoted people in this world with perverted ideologies and demented minds. Unfortunately, however, they succeed in their missions when people react hysterically and go out on a war path to demonstrate their dissent. These bigoted people succeed in their attempts to deride another religion

when the practitioners react in the violent manner that we witnessed in the most recent cases. Instead of words and other means of protest available through the media the people in these countries took to the streets and destroyed whatever came their way. Since the perpetrator of the insult was not at hand, the anger was directed at the country of the perpetrator's residence. It did not matter that the individual was never sponsored by the country or its government.

One needs to pause and ponder why our people react the way that they did time and again. It is easy to explain it away as venting of frustrations and indignation built over grievances against Western powers that people in some countries have been nurturing for some time. Incidents like the most recent ones only trigger these frustrations. But it does not explain why people in some countries take to violence against their own people citing insults to their faith at the slightest provocation.

A couple of months ago in Pakistan a whole village rose up in arms to protest an alleged incident of burning pages of the Holy Koran by a minor girl of another faith. The girl was arrested and put in jail, but later released as the allegation was unfounded. But the alleged incident inflamed the majority community of the area to such an extent that the entire community of the minor girl felt unsafe and was prepared to leave the area.

Now we have in Bangladesh the terrible happenings in Chittagong Hill Tracts where the majority community has

gone on a rampage against the Buddhist minority for its alleged insult to Islam. A reign of terror was let loose on a helpless community, their property pillaged, and their religious places desecrated all because of an allegation that someone from that community had insulted the majority community's religion. In the frenzy the people who led and participated in this persecution and vendetta in the name of religion against their fellow countrymen never pondered to think how they were violating the edicts of their own religion on excesses and oppressions against other members of the humanity.

It is a copout to attribute these mindless acts of violence and religious intolerance to only righteous indignation of a community to such insults. A much deeper cause of such behavior and intolerance lies in the mindset of a majority of our populations that have been submerged in illiteracy, poverty, ignorance, and low esteem for self and community around them. Poverty and ignorance have led our people to put blames on others for our failures, distrust of neighbors, and viewing any individual attempt to denigrate our faith as an international conspiracy to subjugate us. Poverty and ignorance also makes them prey to manipulation by religious zealots, and political opportunists.

In countries with low level of education, wealth, and a high degree of unemployment, the potential for easy outbursts on any pretext among the population always exists. Usually the pretexts are provided by domestic political situations in these countries. The pretext provided by religious affronts,

however, creates a diversion from domestic politics, and our political leaders get a respite from political oppositions from such diversion. They either ignore these or encourage these protests for short term popularity often at greater peril for the nation as a whole.

Insulting beliefs or faith of any community is a reprehensible act and it needs to be stopped. Constitutions of most democratic countries provide safeguards for all religions and forbid such egregious acts. Yet from time to time we have incidents where individuals or groups who either wittingly or unwittingly take to acts that hurt the religious feelings of another community. Unfortunately the reactions in our parts of the world to such gratuitous acts of individuals are often violent, deadly, and self-defeating. Instead of addressing a wanton act of provocation by an individual in a clever and more productive and helpful way we project an image of greater intolerance and bigotry with our counter violence.

No religion teaches violence; no religion teaches how to insult or denigrate other human beings. People who wear religion in their sleeves need to remind themselves that freedom of religion is the cornerstone of religious tolerance; and it is clearly established in the Qur'an ("There is no compulsion in religion"- Sura 2:256).

The image of a country or that of a community is not simply derived from what it believes in, but also from what it practices. A democratic country is not democratic simply

because it has a constitution that advocates democracy; it is democratic when others see that democracy is practiced in that country. Religious tolerance and respect for all human beings cannot be ensured only by inserting these in the constitution of a country, it can be ensured when all people of all faith are protected equally by the state. Violent reactions to insults by individuals to any faith are not the way our religion teaches us, least of all by unleashing these reactions on people who cannot retaliate. Our political leaders need to guide the people in such occasions with stern actions when frenzy replaces sanity.

In our country's present state I hope that all efforts will be directed to preserve the lives, property, and rights of people of all faith. This is what the country's founder promised to his people, and this what we would like to see to be delivered.

Iraq War Version Two

After much hand wringing, and running through all possible options the US decided to enter again into Iraq space more than two years after it had withdrawn all its troops from that ill-fated country. Ostensibly this second entry, albeit a very limited one, began as humanitarian aid to rescue a minority sect of Iraq forced by the Islamic militants fighting in the name of Islamic State of Iraq and Syria (ISIS) to flee their townships to remote mountains. But now it has turned to air attack on ISIS forces to drive them out of Iraq towns occupied by them with support from Kurdistan troops who are purportedly helping the anemic Iraqi government to recover territories lost to the militants. At the time of this writing the air strikes by US have been able to drive the ISIS militants from some strategic areas of Iraq, which they had occupied from a thoroughly demoralized and dilapidated Iraqi army.

If the current intensity of US air attack continues for some time, and the ragtag Iraqi army is able to remobilize and regroup with renewed strength under new Iraqi Prime Minister, it is possible that the ISIS militants will retreat to their strongholds inside Syria, and Iraq may gain the lost territories back. But there are too many imponderables in this scenario, the most difficult of which is the ability of the Iraqi army to regroup and remobilize. The follow-through battles after US air strikes in the ISIS held region were mostly fought by Kurdish troops who came out to secure

their autonomous region from the militants initially, and then lent support to Iraqi government forces. In fact, it is doubtful if the militant occupied territories could have been regained with only Air strikes without Kurdish ground support. The second biggest unknown is the ability of the new Iraqi government and its Prime Minister to forge a coalition of unity in Iraq that fractured by sectarian and ethnic divisions. The abject failure of the previous Prime Minister Maliki to show a minimal semblance of sectarian unity and his rather open bias toward his own sect in official acts and public policy led to wide disgruntlement among other minorities, in particular the Sunnis. In fact, a major reason for the reportedly cordial reception to ISIS militants accorded to the Iraqi towns captured by them was because the residents had become resentful and antagonistic to the Maliki government. The militants, who all professed to be Sunnis, in a way had become their liberators. So the challenge to the new Prime Minister and his government would be to allay these fears from the Sunni minorities as well as the now powerful Kurds who would like to retain their autonomous status with complete ownership of their oil wealth.

A third big puzzle is ISIS itself. It is simplistic to explain it away as a terrorist organization. But it is much more than that. In a time span of less than a year the group emerged as the most powerful of all the armed groups that were fighting against Assad regime in Syria. But while other anti-Assad forces were simply fighting Assad army and driving them from cities, the ISIS militants were

focused on not only driving Assad forces from the cities, but also trying to establish Sharia Laws in the areas they occupied. They proved that they were not simply seeking to oust Assad government, but to establish a government according to their interpretation of Islam, and laws they thought appropriate. Hence their desire to fan out and stake their claims on bigger territories to spread their concept of government and laws this government would implement. ISIS may retreat from the areas they occupied in Iraq, but it will regroup and channel its forces to other areas in and around as soon as the current air attacks abate and follow up ground forces return to normal mode.

This second phase of war in Iraq may end quickly if the mission is only to oust ISIS from Iraq. But it may be protracted if the mission expands to eradication of ISIS militants from that geographic area that conjoins several countries. Air strikes will temporarily dislodge the logistics and locations of the militants, but to drive them out of the habitats they have selected now it will require more coordinated effort of all the countries in the region including Iran. It will require a strategy both long and short term that will be agreed upon by the countries and their allies in the west aimed to end religious militancy.

Militancy cannot be an end by itself. It is a means to an end, it is a tactic to achieve a goal. The mission of the current militant movement in Syria and Iraq is to establish a system of governance that was meant for a society in the distant past that had just come out of ignorance and idolatry.

Unfortunately the group is trying to foist on people the same system in the name of religion with a harshness that contradicts the main teaching of Islam, which is tolerance and moderation. The countries within the region need to wake up to this threat and stop it before it causes irreparable harm to them.

Any movement whether militant or peaceful is sustained by support direct and indirect. The direct support comes from resources, finance and manpower, that the movement receives from its ideological sympathizers, and political opportunists. The indirect support comes from countries that fail to resist such movement within themselves. The ISIS movement will continue to remain a threat to the region as long as the region itself, particularly Syria and Iraq remain unstable. It may go underground under Air attack and resurrect itself when opportunity strikes. It can only be stopped with concerted actions of all countries in the region including Iran. We do not know if that day will ever arrive.

Misadventure of Muslim Youths Abroad

Muslim Bangladeshis living in UK recently became focus of interest to all Bangladeshis living home and abroad when the news of some Muslim youth of Bangladesh origin joining the so-called Islamic State in Syria/Iraq struck the front page. Among them were two or three young women, and a whole family that included even some elderly members, men and women. Youths leaving a relatively prosperous country for a war torn, failed state that had succumbed to a militant group was astounding news not only to their families but also the country that they decided to leave. Yes, among the youths joining the jihad brigade there were other Britons of other national origin too, but the news getters were the young Bangladeshi females and the big family of eleven or so who left for Syria leaving their home of decades in Britain.

The militants in Syria and Iraq calling themselves the Islamic State (or ISIS) have grown in strength over the past two years drawing youths from different parts of the world including Western Europe, United Kingdom, even from the US. It is reported that there are over 4000 foreign fighters who have joined the ranks of ISIS, which primarily consists of rebels from Syria and is believed to be militarily trained and supervised by ex-members of Saddam Hussain's formidable army. The military prowess and tactics that ISIS has shown in overpowering the Iraqis as well as the largely depleted forces of Syria's Assad are evidence of a

well-trained force that goes beyond the normal fighting strength and longevity of a typical rebel force.

The sustained war in Syria by ISIS along with its success in holding on to a sizeable territory of Iraq for nearly two years established its credibility among the Islamic fighters many of whom have been active in the Middle East as well as Afghanistan and Nigeria. ISIS emerged as the strongest among the militant organizations not only because of its organization, but also because of the ambivalence of the Middle Eastern nations toward intervening in the current war and half-hearted attempts by Western powers to stop the war. The ambivalence of the Middle Eastern countries, particularly Saudi Arabia and the Gulf States, partly comes from their fear of Shia domination in that area with Iraq now falling mostly into Shia leadership, a potential Iraq-Iran entente rising in the horizon. (Shias are sworn enemies of ISIS.)

ISIS grew as much for what it did for itself as for what the other countries inadvertently did for its growth. It developed into a mighty fighting machine enough to declare itself a Caliphate and asked all Muslim countries to join its cause, even asking them to recognize its supremacy. People have not joined them in droves, but it did appeal to a good number of youths spread over distant lands to join its ranks. And many have joined, not just attracted by the romanticism of the adventure, but also deluded by the religious appeal of joining a grossly misinterpreted holy war.

Attractions of Muslim youths, particularly in the west, to this cleverly constructed holy mission has been variously attributed to disenchantment and disengagement of the youth from mainstream culture of the adopted country, failure to assimilate in the society, and a perceived sense of discrimination by mainstream society. It has also been attributed to a growing urge among the youths to seek a different identity from the mainstream based on religion alone since this identity provides them a bigger platform and strength in number. It covers a wider range of people from different ethnicity. Added to that also is a perceived sense of persecution world wide of people of their own faiths which has been constantly hammered into them by clerics with a political agenda of their own, both home and abroad.

Absent from the above analysis is how much religious teaching itself is an important driver of the youths wanting to relinquish their adopted home and fight side by side with forces that are not exactly their friends. Immigrants to UK, US, and other European countries come from all parts of the world with all kinds of religious and ethnic background. Yet, in UK or US one does not hear of complaints of alienation or exclusion by immigrants that practice religions other than Islam. One does not hear of extremists or people in the fringe from these communities who had turned so because they felt alienated or discriminated. This does not prove, however, that discrimination against minorities does not exist in these countries. But they challenge this discrimination in ways that are legal, and are supported

by the laws of the country. Most other minorities not only abide by the laws but also they know how to take advantage of the legal system of their adopted countries if, and when they are discriminated against. They do not take out their grudge against the society by taking resort to extreme measures or by violence.

Unfortunately a large number of Muslim youths, whether from South Asia or West Africa have been brought up in an environment which is devoid of the most fundamental teaching of their religion, tolerance and acceptance of all other religions as equal to their own. This education they neither receive at home nor the places where they go for worship. They have been taught at home how not to integrate at school because of religion, food habits, and culture. As a good number of these youth grow in ethnic and religious islands the teachings from home and community places harden them into individuals with rigid mindset. They find it difficult to assimilate at a later stage, at work place or higher places of learning when they come out these shells. They find themselves as misfits, and they snap out.

Joining a jihad brigade provides as a kind of escape for these youths from the hard reality they face. But they find it equally difficult to return when the romantic adventure does not pan out to be the place they were looking for.

To stem this tide of false attraction, for all the disgruntled and alienated youths the right place to start is home. They need the basic education of having respect for humans

irrespective of religious faith. They need to be told that alienation from the country they live in on grounds of religion or rejection of other religions cannot lead them to happiness or success. The Islamic State or ISIS is a political game that will not deliver to them the life their parents expected of them, or the one that their adopted country offers to them.

Terrorism in any name is bad as it sounds

The most recent act of terrorism in Paris shook the world, but the victims of the terror acts are not confined in the city of Paris alone. The direct victims may be those who died in these sordid actions, but the other collateral victims are from the community to which the perpetrators apparently belonged. And unlike the dead victims the collateral victims are spread worldwide. This is not just because the perpetrators happened to be Muslim, but also they revealed either through their utterances or association that they undertook these violent actions in retaliation for what they perceived as act of aggression by some western countries against Muslim countries.

Muslims all over the globe, at least the overwhelming majority, were obviously shocked and ashamed that people from their faith could launch such cold-blooded acts of terror on innocent people. But they have been shocked before several times in the past by similar incidents of terror that were unleashed on innocent people in various parts of the world including Muslim majority countries by people claiming adherence to the faith and more shockingly they did carried out these acts in the name of Islam.

Muslim reaction to these terror acts by fellow Muslims can be categorized in three groups. The great majority of the Muslims have expressed deep shock, sorrow, and disbelief. They have denounced these as un-Islamic, acts that Islam never condoned. A second type of reaction has

been one that did not condone the act but termed the act a reaction to the acts of aggression against Muslims in various parts pf the world. The third kind of reaction is mostly in countries unaffected by such violence where such acts of terrorism are attributed to the frustrations and alienation of a marginalized, unassimilated immigrant population.

To all these incidents has been a vigorous shaking of the head noting their disapproval followed by a unanimous disclaimer that their religion does not condone such acts. Beyond that I have yet to see a firm action plan or program that aims to help their co-religionists to address such deviant behavior and anti-Islam acts that are increasingly posing a threat to their combined image and existence with other communities. When a person claiming to be a Muslim performs an act that harms any community in the name of religion he is not only hurting the target community but his own community at large as well as the religion he professes. It does not matter if the heinous act takes place in a country other than his own, or in his own country. The Boston bombers (reportedly) claimed that their act was an expression of anger and retaliation for Western aggression against Muslims. The machete wielding killer in London declared that he was taking revenge for UK aggression in Muslim countries.

Individualized religious radicalism or extremism does not happen in a vacuum. Tolerance and acceptance of diversity in opinions, and respect for other human beings is fundamental for a society. When these values are not taught

in a society extremist and xenophobic ideas take root. We see reflection of these in many developing countries. The other contributors to the rising threat of individualized or group radicalism are feelings of isolation, blame games for personal or national failures, or finding a common enemy for these failures. I am going out on a limb to explain such behavior, but I would venture to attribute much of the past happenings of extremist and terrorist incidents to some of these factors. However, while these may explain partly the reasons of some lone wolf behaviors, these are not adequate to explain the mindless killings of fellow Muslims by other Muslims. This, I am afraid, has much to do with what social values that a child in those environments grows with.

Unfortunately in many parts of today's world, along with poverty, absence of knowledge of human rights and right for diversity of opinions, and above all the ignorance of right to life and property is widespread. This has never been taught in schools, and least of all in many families. Add to all of this the political propagation of seeming injustice to groups or sections of people of a particular faith, and the proclivity of less privileged people of the world to put blame for their lacking on nations of wealth and power. Otherwise we cannot explain why Muslims bomb their own kind in their own soil. Otherwise we cannot explain why an individual gets radicalized to the extent that he is ready to sacrifice his life to exterminate hundreds of other human beings. It is possible that in some cases an individual's conduct is driven by his demented psyche (probably that is why he is driven to this psychotic behavior). But I would say that

I most cases this senseless behavior has much to how this individual has been trained by his environment and the education he had received.

I have borrowed the title of this piece from a commonly used term by Web Programmers—what you see is what you get. The intent is to drive home in our mind is that in today's world of individualized or group religious extremism what we see is what we get from how we train our young mind. Radicalism does not exist in a vacuum. It comes from absence of respect for human life, respect from a diversity of opinions, and tolerance. People who take up arms in the name of Islam first remember that Islam is one of the religions that places right for human life, respect for all religions, and diversity of opinions above everything else.

Terrorism- the ultimate bigotry

Terrorists struck again, this time in Paris, France, killing ten journalists and three policemen. (The two suspected terrorists were killed two days later by French Police in an armed resistance). Ostensibly, this latest terror attack was to take revenge against the editor and publishers of a cartoon magazine who allegedly spoofed Prophet Mohammad. In their own words the two perpetrators snuffed out lives of eleven people because they were enraged by what they considered to be insult to the Prophet of Islam.

Protests by Muslims against any purported ridicule of their religion or prophet have been staged before in Europe and elsewhere. People have been outraged and some demonstrations had taken some violent form also as in Denmark, Netherlands, and few other places against satiric comments, offensive videos or cartoons making fun of Islam. Such demonstrations are understandable because they hurt people's religious feelings. As is also understandable the rights of free speech and expression of those who publish these items.

There is a lot to be said about freedom of speech and journalistic freedom, as there is also much to be said for respect for all religions and people's feelings. But there is nothing to be said about barbaric response to rights of expression in the name of defending religion. This type of response befits only medieval societies where honor killing is a badge of honor. But Paris killing is no way any Muslim

can identify with whether it is to defend the Prophet or their religion. It is the act of demented people who take shelter of religion to justify their violence.

The most regrettable part of such tragic events is Muslim reaction to these occurrences. In last twenty years out of ten terrorist attacks in Europe eight were perpetrated by Muslims. In all cases as in this most recent case indignation has been expressed by Muslim leaders in Europe and elsewhere to denounce such brazen attacks and taking lives of innocent victims. In all cases attempts have been made to distance so-called mainstream Muslims from such heinous acts. Their message has been that such heinous conduct and taking of lives is not condoned by their religion. Islam is a religion of peace and its practitioners, by and large, are peaceful people.

Unfortunately, this message does not bear any credibility any more, not only to people who follow different faiths, but also to people who do not believe any religion. Even many Muslims who watch somewhat helplessly these wanton acts of terror ask themselves why people of their faith are turning so violent. Is it really carried out by only people who have been marginalized in a predominantly non-Muslim society? Does it really grow from a sense of alienation in a society or country that a minority cannot adapt to? Is it a sense of deprivation of the privileges that are accorded to the majority in the country of their adoption?

Unfortunately none of these can properly explain the mindset of a people who continually resort to violence in the name of religion. The minority psyche and marginalization syndrome can partly explain behavior of these people in a non-Muslim society. But how do you explain the mayhems that are daily conducted in many Muslim countries such as Pakistan, Iraq or Syria? Targets in foreign countries are usually non-Muslims, but the targets in Muslim countries are fellow Muslims. If the so-called radicals are taking out their violent acts to defend their purported insult to religion, who are they taking revenge against when they kill innocent children in schools or bomb mosques in their own countries? Surely these are not acts of a few misguided people. These are acts of a determined group of people who have their own interpretation of religion and they are committed to implement it by any means, terror, horror, or dread.

The hour of examination for Muslim countries and Muslim leaders globally is now. They cannot sidestep the issue by attributing these acts to aberrant behavior of marginalized youths. They have to see what is that draws these elements to their religion and propel them to take such heinous acts. Why is that thousands of youths are attracted to militancy and suicide squads and embark on missions any rational mind would shirk?

An answer may lie in the preaching and training many of them receive from religious institutions and their so-called religious trainers in mosques and madrassas. In Pakistan

and some other Muslim countries such training is imparted by religious institutions that survive any monitoring, and may even receive state patronage. In other communities, particularly non-Muslim countries it is benign negligence.

It is time that Muslim communities all over wake up to stem this tide of hate and violence and spreading of terror strikes from their own people. The first place to start is their homes and tutoring their children in human values of respect for life, tolerance, and love—the values their religion teaches. Next place is the broader community and participation in all the community does instead of confining themselves to their own. The last and not the least is standing up against the threat of the zealots who are poised to hijack their religion through their own brand of Islam.

What You See is What You Get

Two recent terrorism related violent incidents, though happening thousands of miles apart in two separate continents, had the overseas Muslim population astir. This is not just because the perpetrators happened to be Muslim, but also they revealed either through their utterances or writings that they undertook these violent actions in retaliation for what they perceived as act of aggression by some western countries against Muslim countries. One (in UK) even went on to quote from scripture (albeit very erroneously) justifying his heinous and dastardly act. The co-religionists of these perpetrators all over the globe, at least the overwhelming majority, were obviously shocked and ashamed that people from their faith could launch such cold-blooded acts of terror on innocent people. But they have been shocked before several times in the past decade by similar incidents of terror that were unleashed on innocent people in various parts of the world including Muslim majority countries.

The reaction of the Muslims to all these incidents has been a vigorous shaking of the head noting their disapproval followed by a unanimous disclaimer that their religion does not condone such acts. Beyond that I have yet to see a firm action plan or program that aims to help their co-religionists to address such deviant behavior and anti-Islam acts that are increasingly posing a threat to their combined image and existence with other communities. When a person claiming to be a Muslim performs an act that harms any community

in the name of religion he is not only hurting the target community but his own community at large as well as the religion he professes. It does not matter if the heinous act takes place in a country other than his own, or in his own country. The Boston bombers (reportedly) claimed that their act was an expression of anger and retaliation for Western aggression against Muslims. The machete wielding killer in London declared that he was taking revenge for UK aggression in Muslim countries.

Contrast these incidents with what happened recently in Muslim majority countries. The Pakistani Taliban routinely attack and kill fellow Muslims (Pakistan Army and civilians alike) in North West of Pakistan to take revenge for the government opposition to their demands. In the two consecutive months this year, bomb blasts have killed hundreds of Shias in Quetta, Pakistan, bombs that there planted by fellow Muslims from the Sunni sect. In Iraq killings by one Muslim sect by another is routine phenomenon now. And I do not want add to this litany of grotesque killings by mentioning what is going on in Syria. If the attacks on Western soil were a revenge against acts of aggression the West on Muslim countries, how do you explain attacks by Muslims on fellow Muslims?

One typical comment that I hear from fellow Muslims on lone-wolf acts of violence or terrorism is why these acts are not termed as actions of a psychotic killer or sociopaths similar to those individuals who were responsible for numerous killings. Well, I have a simple answer to this.

The other perpetrators did not cite a cause for their deviant behavior, or if they did they put it on the society. They did not take shelter behind their faith to exonerate themselves from their hateful acts. But the others cited above did. They claimed that they were taking revenge for aggression against their faith and co-religionists. Ironically, it would be their co-religionists who would be disassociating themselves from such acts. And the greater irony is that such violent acts continue to happen. Why do these happen?

Individualized religious radicalism or extremism does not happen in a vacuum. Tolerance and acceptance of diversity in opinions, and respect for other human beings is fundamental for a society. When these values are not taught in a society extremist and xenophobic ideas take root. We see reflection of these in many developing countries. The other contributors to the rising threat of individualized or group radicalism are feelings of isolation, blame games for personal or national failures, or finding a common enemy for these failures. I am going out on a limb to explain such behavior, but I would venture to attribute much of the past happenings of extremist and terrorist incidents to some of these factors. However, while these may explain partly the reasons of some lone wolf behaviors, these are not adequate to explain the mindless killings of fellow Muslims by other Muslims. This, I am afraid, has much to do with what social values that a child in those environments grows with.

Unfortunately in many parts of today's world, along with poverty, absence of knowledge of human rights and right for

diversity of opinions, and above all the ignorance of right to life and property is widespread. This has never been taught in schools, and least of all in many families. Add to all of this the political propagation of seeming injustice to groups or sections of people of a particular faith, and the proclivity of less privileged people of the world to put blame for their lacking on nations of wealth and power. Otherwise we cannot explain why Muslims bomb their own kind in their own soil. Otherwise we cannot explain why an individual gets radicalized to the extent that he is ready to sacrifice his life to exterminate hundreds of other human beings. It is possible that in some cases an individual's conduct is driven by his demented psyche (probably that is why he is driven to this psychotic behavior). But I would say that I most cases this senseless behavior has much to how this individual has been trained by his environment and the education he had received.

I have borrowed the title of this piece from a commonly used term by Web Programmers—what you see is what you get. The intent is to drive home in our mind is that in today's world of individualized or group religious extremism what we see is what we get from how we train our young mind. Radicalism does not exist in a vacuum. It comes from absence of respect for human life, respect from a diversity of opinions, and tolerance. People who take up arms in the name of Islam first remember that Islam is one of the religions that places right for human life, respect for all religions, and diversity of opinions above everything else.

Was Middle East better off with dictators?

Among issues discussed in debates by the current pack of US Presidential hopefuls of both parties, foreign policy is one hot topic. Each candidate has expressed his or her iron will in formulating a strategy for eradication of terrorism and, of course, sternly dealing with the rising menace of Islamic militancy in the Middle East. Some candidates, notably Donald Trump on the Republican side and Bernie Sanders from the Democratic, have been very vocal in putting the blame for the current crisis in the Middle East and rise of the militant state on Iraq war. And that discussion has led one of the Presidential hopefuls, Ted Cruz, suggest that may be the Middle East was better off with the past governed by dictators. Did Ted Cruz make a Freudian slip, saying something that might have been in the subconscious of mind of many people?

It is hard to imagine that the vast swath of territory commonly as the Middle East that straddles two continents and comprises ten different countries was a generally docile place a decade ago where hardy any political commotion took place. The occasional murmurs of protest here and there were quickly put down or were never heard even inside the countries themselves. The heads of government in Egypt, Iraq, Libya, Syria, Tunisia, and other neighboring countries ruled with an iron hand for decades on with nary a threat to their regimes, and the rest of the world was none the worse for what happened in those countries with the

dictators. There would be some reports of human rights abuse and suppression of freedom of speech that would be carried by the liberal media in the west, but generally the western governments looked the other way as their national interests were not in stake by domestic actions of the dictators.

But that was until Saddam Hussain was toppled after US invasion of Iraq in 2003 ending his long rule of nearly a quarter century. Although an end to Saddam's rule was brought by war launched on Iraq by US and allies ostensibly to punish him for his support to terrorists and harboring so called weapons of mass destruction, the end to his long rule opened the Pandora's Box of decades of ills that had remained hidden not only in Iraq but also adjoining areas. The demise of Saddam brought an end to his iron rule but it also released internal forces of sectarian opposition and ethnic hostilities that Saddam and his Baathist party had ruthlessly suppressed. The end to Saddam regime did not lead to ushering of a new dawn of democracy and freedom for the Iraqi citizens; it pushed them to a new era of mayhem and complete breakdown of law and order that ended in civil war between Shias and Sunnis, Iraqis and Kurds, and gave birth to militant Islamists seeking to establish a new order.

While Iraq battled one crisis from another with a weak government and a rag tag Army that was completely depleted of its former ferocity in Saddam' time, a new wave of popular movement against dictatorial regimes

pounded the shores of other Middle Eastern countries. A revolutionary wave of demonstrations and protests (both non-violent and violent), riots, and civil wars in the Arab world known as Arab Spring would spread from one end of that region to another beginning with Tunisia and running through Egypt, Libya, Syria, and Yemen.

By the end of February 2012, four rulers had been forced from power (Tunisia, Egypt, Libya, and Yemen0 and one ruler (Syria) was fiercely fighting his existence while losing territories to rebel forces. There were other civil uprisings also that had erupted in the region but these subsided because of lack of support from general population and more importantly the armed forces.

Today the Arab Spring has turned into Arab winter for its spectacular failure to bring about the changes the protestors wanted to bring in their countries after the fall of the dictatorial regimes. Except Tunisia almost all of the countries that cheerfully toppled their regimes in the hope of democracy, freedom and individual liberty, are still fighting internecine civil wars, breakdown of law and order, and living a nightmarish existence.

After four decades of economic progress earned primarily through oil revenue and a stable albeit ruthless government, Libya is in shambles now. It is practically a country without a formal government as it is divided in two parts, one under a legally elected government and the other seized by militants who call themselves Islamic state. Yemen,

where a popular upsurge led its autocratic President agree to surrender power in 2011, has now become a failed state after the hostilities between Shia Houthis and the government forces broke out in 2013. The country has practically no government as war between the Shia rebels and the Sunni controlled government forces aided by Saudi Arabia ravages the country.

After a short stint of democracy in Egypt where a new government was installed after the country's first free and fair elections after Hosni Mubarak, the army stepped in to put down another set of civil riots against the new government. The country is back again under a former Army chief who formed a new government after fresh elections that many think were engineered.

While the countries that were able to change governments struggle with their new wars, the crisis that has taken center stage in the Middle East is Syria where the four years of most vicious and destructive internecine war goes on with unabated fury and bloodbath. Survival of this last bastion of dictatorial regime has been possible mainly due to lack of a united action plan among western powers on disposal of Assad regime, and support to the regime given by Iran and Russia. This ambiguity among western powers as well as breakdown of Iraq as a unified country helped grow a third front in Syria, the Islamic State, which was able to solidify its strength by occupying territories of a fractured Iraqi state and parts of strife torn Syria. This new entity has cast itself as a force more dreadful and threatening than

President Assad and his government. Dilemma for the west now is who to get rid of first, a dictator who is suppressing only his own people, or a militant group that threatens the whole region as well as the West?

No one knows if and when peace will return to the Middle East and lives of people there will go back to the days they were in decades ago. It is cynical to suggest that these countries were better off with dictators. It is decades of iron rule and suppression brought the countries to where they find themselves today. But it is tempting to long for those days for its citizens because they had roofs over their heads, and they did not have to leave their homes for work with fear of deaths looming over their heads. Probably that day will return, but only after the citizens in those countries get unified to fight the enemies of sectarian and ethnic strife that afflict them now.

US Conundrum in Syria

President Obama's decision to seek congressional approval before a reprisal against the Assad regime in Syria for its alleged use of chemical weapons against its own people took the world by surprise. Only a few days before both President Obama and Foreign Secretary Kerry had spoken in strongest terms against Assad and had all but pressed the button on the missiles heading toward Damascus. President Obama had declared that the "redline" had been crossed by Syria and it was time that the regime was taught a lesson. The battleships were ready, and many residents in Damascus reportedly were ready to evacuate. But the missiles were not launched, and bombs were not dropped on Damascus or the Presidential palace there.

Political pundits here and abroad have opined that two factors made President Obama change his decision—British parliament's vote against a Syria attack, and dissension among members of his own Democratic party in the Congress on starting another war. Although seeking Congressional approval before launching an attack on another country is not obligatory for the President, Obama made a clever move to shift the onus of making the decision on Syria to the Congress. If he were to go war with Syria he would like the majority of members of the Congress (100 Senators and 435 Congressmen) to give him the green signal. Will it happen?

The hand wringing over going to another war in the Middle East had been going on since the current civil war in Syria began more than two years ago. Citing examples of supporting rebel causes in Libya and helping to topple Gaddafi there, hawks in the US have been urging President Obama to side with the rebels and help bring down another Middle East dictator. Yielding to growing demands for military support to the rebels, at one stage the Obama administration had talked about limited military support to the rebels which, however, did not materialize for many reasons.

Unlike Libya, the Syrian civil war proved to be more long lasting as Assad regime had several advantages in its favor. Primary among these were solid Russian backing both materially and diplomatically, and support from Iran and Lebanon's Hezbollah for a fellow Shiite regime. Disagreement among Arab countries for a common approach toward opposing Assad also helped the regime considerably.

Another factor that contributed to dilly dallying of Western military support (particularly US) for the Syrian rebels was alleged participation in the rebellion by Islamic militants. There were media reports late last year of efforts to introduce Sharia laws in some areas under the control of rebels with Al-Qaeda affiliation. These obviously led to fears in the West that weapons purportedly given to support a rebellion against Assad regime could land among groups that are openly against West. Such a military support could be

self-defeating for the US and Western Countries. Another distraction came earlier this year from the Egyptian crisis with Morsi's fall and military takeover of that country. The US has more at stake in Egypt than Syria.

The game changer for Syria has been the regime's apparent use of chemical weapons against its people, and deaths of children and women from the use of such weapons. The horrifying images of such mindless attacks and the victims caused considerable sympathy and outrage in people's mind giving additional fuel to the hawks for stopping the regime militarily. Most vocal among the Senators and Congressmen have openly urged the President to give an adequate response, by attacking Syria. The doves have been less vocal, but they made it known either by interviews or surveys that do not want another war.

Lost in this rhetoric on both sides is the voice of the people, which in the absence of a referendum can be heard only from occasional rallies or opinions given through the media. On the surface it would seem the public is divided like the Congress. The country is suffering from fatigues of two Wars, and it can ill afford another, either financially or psychologically. People watch and see the sufferings in Syria as they have seen before in similar other countries. But should US be interested to save and rescue every other country because its leader has launched a war on his own people, or because groups in that country are engaged in an internecine war? Unfortunately the hawks do not care

for public opinion; their focus is on a strategic interest that common people cannot relate to.

A decision on whether to launch an US attack on Damascus will probably be known in a week after both houses have gone through the deliberations in their respective Foreign Affairs Committees. The most recent survey by the Washington Post (September 3) reveals that out of 100 Senators about one third is either against it or leaning toward opposing the attack. The rest are either undecided or favor the attack. In a survey of 189 Congressmen less than half are either against the war or leaning toward opposing it. More than half of the surveyed Congressmen are either undecided or favor the war.

The survey may not reflect the final outcome of Congress vote, but the future of the war in Syria and people affected by it are riding on this outcome and the President's decision following the vote. The civil war in Syria has caused more than 100,000 deaths in two and half years, and has turned over two million people into refugees in neighboring countries. The US is between a rock and a hard place in choosing an option. A complete non-response will further bolster the criticism of the President for his failure to stop a brutal dictator, and encourage continued oppression of Syrian people. On the other hand, a military response and attack on Syria will be viewed by critics of the US as another brazen attempt to destroy a Muslim country. The irony is that the latter critics do not appreciate how Syrian

regime is itself leading the country to destruction by its own action.

The US Congress may endorse Obama's plan of action or it may not. Finally, Obama may nor may not act by Congress recommendation. All we can hope for is a sane approach to end this insane war. A new war may not be the right answer.

Terror in Dhaka-- the inevitable happens

After months, probably years of denial and self-deception about existence of militant radicals tied to foreign groups our government woke up to the reality that everybody had been warning us about all along. The militants raid and hostage taking with two known deaths (and perhaps many more) in the Gulshan café may be unprecedented in Bangladesh history, but in the annals of recent terror history, this is just one more incident. Could this horror have been avoided? Perhaps yes, perhaps not. What is undeniable, however, is that this is a terror act that was waiting in the wings for a long time, and it finally happened. Sad that it took two young police officers' lives and made victims of innocent foreign citizens many of whom were working in Dhaka for a living.

The bloody drama of Gulshan café is still unfolding as I write this piece. The number of deaths is not fully known, but at least two dozen lives caught in that trap are in great danger. We hope fervently that somehow a total blowout will be averted, but knowing that the militants who are occupying the café have yet to make any statement regarding their objectives, there are only speculations about the outcome none of which is pretty. Various claims have been made regarding the affiliation or sponsorship of these terrorists, ranging from the Islamic State to Al-Qaeda to local home grown groups-- the usual suspects. Foreign media have in the meanwhile made Dhaka a centerpiece

of the latest terror attacks, and are attributing the attack to either of the two infamous international militant groups. Additionally, the foreign media are also pointing out our government's failure to hark to the signals that the country had been receiving from the wave of killing of individuals, foreigners, bloggers, and religious minorities. In fact, this incident has stirred up the critics to come out in full force to blame the government for the failure to reign in budding militants in the country.

We do not know actually who the sponsors are, what the motive of attack is, and least of all who the attackers are. Are they all our own nationals or do they have some foreign collaborators? Coming in the wake of Istanbul attack, we cannot fully rule out the presence of foreign elements among these attackers.

It will not take time for this horrific incident to come to a closure, perhaps before the time this article goes in print. But what is certain to happen is that this will bring in its wake more deaths, and turn the city to a gloomy and melancholy place at a time when everyone is about to celebrate the end of a holy month with festivity. The blood that has already been shed by our two brave police officers who were killed and dozens wounded has already cast a pall of gloom. This will be only darkened further with losses yet to come.

We will probably be splitting hair for days to come figuring out how it happened, and there will be more blame games going round. But if there is one lesson to be learnt from

this tragedy is that surveillance alone cannot stop such terror acts. We may have hundreds of guards and policemen keeping eyes on a people trying to prevent the rogues from attacking. But it takes only one determined group of people to outwit and outsmart these guards through their ability to network and amass enough fire power to launch such blitz.

Terror acts of the kind that just happened do not happen all of a sudden. These take days and months of planning, preparation and assembly. At this time I do not know if there is foreign involvement at all, and I will not rule it completely. But I have written before and I reiterate it now that radical extremism of the kind that is now on display globally does not crop up suddenly in a country without a nexus of ideas that run across countries. The terrorists who took over the Gulshan café, and carried out their nefarious acts could be all our own nationals, but they drew their inspiration from a bigger cadre of militants who are pursuing a mission that threatens all countries of the world, irrespective of cast, creed, or religious belief.

It is sad that our government despite its commitment to fight and contain global terrorism, failed to recognize the enemy within. By putting blames on opposition parties and their putative agenda to embarrass the government in the past, we have allowed our law enforcing agencies to lose their focus on the real danger that was lurking the country and was getting bolder by day. There have been many evidences of the growth and strength of these elements in the past, but for strange reasons our authorities ignored them.

The cost of political blame game is heavy as we can see from this ongoing incident. Neither rhetoric nor political blame game can replace real action to contain the cancer of radical militancy. I am not suggesting that terrorism of the kind that is threatening the world today can be prevented easily, but at least our energy can be well spent, resources better used to fight the cancer of militancy if our politicians agree to put aside their differences and fight jointly.

As of this time, the crisis in Gulshan is not over. I am praying and hoping that it comes to a closure without any more bloodshed. But what I am hoping most is that there will be transparency in police action, and we will get to know who the perpetrators were. Let there be no murkiness to explain this to the nation. We deserve it.

The stalled war against Islamic militants

The war against the so called Islamic state (ISIS) is about to have its first anniversary. There is no sign of any immediate end to the war neither to the hold of the militants over a sizeable of chunk of land in Syria and Iraq. Despite the efforts to dislodge them by air strikes by Western nations including the US, the territory in ISIS control remains pretty much the same (the size of many Middle Eastern countries).

The air strikes caused ISIS militants some set back, and halted their aggressive further advance. In fact, experts expressed doubt that without ground military intervention it would not be possible to drive the militants from the territory they had seized. But no country was willing to stake a ground support including the US. The matter was left mainly with Iraqi government to strike back with forces at their command, with military advice from the US.

The core of the problem in that part of the Middle East is not just weak government in Iraq and an imploding Syria. The success of ISIS was also a lot due to the sectarian division of the area between Shias and Sunnis. The welcome they received from Sunni territories of Iraq such as Mosul and Tikrit where the Iraqi forces were viewed as oppressors is evidence. But their later ability to hold on to the territory and the apparent slow progress in the war against ISIS have more to do with the ambivalent of the countries in the surrounding area toward a determined effort to eradicate

the forces occupying the area than the military strength of the militants. ISIS successfully exploited that fear and it has been relentless in promoting its appeal to the Sunnis in the area through its protection of the Sunnis from purported Shiite repression under a Shia dominated Iraqi government. (In fact, when the battle to retake Tikrit began a US fear was of reprisal by the conquering Iraqi forces on local Sunnis for their support to ISIS.)

The progress of the ISIS militants in expanding their territory has not been halted by air strikes alone, but the role the non-formal Shia militias is playing in this war. And this is largely because of the role that Iran is playing in this war. Iran is now wielding a greater influence in the counter offensive against ISIS that became apparent in the recent battle around Tikrit. Reportedly Iranian-backed militants are taking a bigger role in the fight against the Islamic state than regular Iraqi forces. Iranian leaders have been openly helping direct the battle, and American officials say Iran's Revolutionary Guards forces are taking part. Here comes the great conundrum that dominates the current war against the ISIS, in fact its continued presence and slow response of the neighboring Arab countries to remove them.

Iran's increasing involvement in the war against ISIS has brought into fore the fear of the Sunni countries of a vigorous Shia presence in the Middle East that may lead to Iran's oversized influence in a vast territory stretching from Iran to Lebanon. The Shias dominate in numbers in the region, but except Iran they were in the political back waters

until the fall of Saddam in Iraq. The new Iraqi government installed Shias in powerful places and lifted the Shias from political repression to political control. Unfortunately this also led to a new political paradigm that reversed the role of the Sunnis from one of hegemony to impotence.

Presence of ISIS in some ways is counterbalancing the strength of Shia influence and political control in the area. The ISIS is playing on the Sunni fear of Shia oppression and back lash once the Shia led Iraqi government regain the territories, and Iran's role in the war will fuel that fear. The Shiite militias on the other hand are motivated by ISIS's belief that Shiites are apostates who deserve death. As a recent report from New York Times states the militias' involvement carries a risk of further inflaming sectarian tensions that ISIS has exploited — as has already happened in some places where Sunni residents have reported abuse or summary executions by the militias.

The war against the Islamic militants of ISIS has to be viewed against the continuing Shia-Sunni strife in the area. The Western powers who would like to see an end to the militant state and the radicals who control it are caught between their reluctance to see a powerful Iran presence containing the ISIS militants, and the implicit support to these elements from the Sunni countries in the area. Restraining and eradicating the ISIS militants and the territory they control would have been easier if the Arab countries in the area were united on the subject and lent

ground support to Iraq forces in this battle, just as Saudi Arabia did last week to stop the Shia rebels in Yemen.

The war against ISIS will become more complex if this is continued to be viewed by the neighboring countries through a Shia-Sunni prism and not as a threat to the existence of all countries in the region. For the ideology ISIS is propagating that harks back to a stern Islamic government is not what these countries want to be thrown into. This is not what the harbingers of Arab spring (albeit deflated now) dreamed of or talked about. ISIS stands against the hopes and dreams that people chanted for in the streets of many of these countries only a few years before.

The West and all democracy minded countries can support only so far as the countries who are directly affected by the ISIS threat want. This can be moral and in some cases auxiliary military support. But the real help and effort to eradicate this threat will have to come from the countries themselves. A sectarian strife and mutual distrust based on sectarian difference will only strengthen ISIS and its expansion. The threat posed by ISIS will remain as long as the neighboring countries do not work together to fight this.

Morsi's Fall and Impact on Democracy

Egypt's Morsi has fallen, and fallen very badly trying to stem a tide of protest against his government, but more significantly trying to stand up to the most powerful institution of the country—the Armed Forces. He has been ousted by the Army because Morsi failed to heed to the protests against his government by people who had been peeved by a failing economy, his political ideology, and assumption of more power for his office. They wanted him to go. His response to his detractors had been that he was elected to the office by popular vote, and he had the right to remain in office to serve his term. Apparently his country's most powerful institution did not agree with him. So, citing people's concerns and demands, they forced him out. And we all want democracy for Egypt. Since when toppling democratically elected leaders by force is democratic?

Morsi may have made many mistakes in his first year, like dismissing top Army officers within first few months. Like many public leaders in many other countries who are elected to office with popular votes Morsi also thought that he had people power behind him. He may have thought that the protests that he encountered in last two weeks were part of the democratic process where opposition vents its disapproval of the government in power, and he wanted to meet these politically with support from his loyalists. Where he went wrong is his apparent belief that he could discount the army's role and influence in the politics of his

country. He may not have into account that this was an institution that has been built over and thrived more than five decades with government help. It has supported and buttressed authoritarians for much of modern Egypt. This seat of power and authority cannot be diminished in a year, even in the term of a President.

Unfortunately, in his tragic discount of the Army Morsi is not alone. In Pakistan, time and again, the Army had intervened to "save" democracy in that country. Most recent example was when Gen. Pervez Musharraf toppled a democratically elected leader, and his country had lauded his actions—albeit to regret this some ten years later. Unfortunately in countries like Egypt, Pakistan, and Turkey (until turn of last century); the Army has been the unofficial guardian of the country. The institution has thrived with the blessings of the governments because either the heads of governments came from the Armed Forces or they were propped by them. The Army in these countries played the role of a parallel government of sorts, and arbiters of political feuds intervening as necessary. It managed to create a squeaky clean of image of the institution by maintaining an official arms-length distance from politicians many of who dived into corruption and thrived in it. Unofficially it carried the power baton that would be wielded to herd the straying politicians to the line it wanted them to follow. Majority of the people in these countries never got an inside view of the palace intrigues. Instead they have been enamored by the show of external discipline and time to time application of force to cow down errant politicians.

The supreme irony of recent uprisings and protests against Morsi and the jubilation of the protesters at the Army's ouster of Morsi is that similar protests were staged by people in the same famous square against the Army prior to last year's election. This protest was staged to remonstrate against the Army's dilly dallying with the election schedule. Thanks to people's protest and the Army's holding of the elections, which were declared to be free and fair by all, Egypt had its first truly democratically elected Parliament and later a President. In the initial days there were tremendous apprehensions in the outside world if this would last, particularly when the new President changed the top brasses of the most powerful institution of the country. The powerful army lost a battle, but not the war. The opportunity came via the massive protests over economic woes, rising prices and unemployment, power cuts and lack of security. The final coup de grace was provided by Morsi's belated response for a political dialogue. By that time the die was cast for him.

But is this the way a democratically elected leader should be shown the exit? Is not ballot the proper answer to oust a government that we do not like? What precedence we establish when we trash a nascent democracy in a fashion that only fits a dictator?

Public memory is proverbially short. We all live in a state of amnesia or pretend that we never faced dire conditions in life before when we face new troubles. People easily forget the dark times of authoritarian or military rule, abuse

of human rights, and absence of freedom. Democracy unleashes people from these chains, but it also bestows some accountabilities and responsibilities that people cannot appreciate immediately. People react sharply when there is a dearth of physical amenities that a dictatorial regime made available to people to keep them happy. It takes time for a democracy to be stable, and people need to realize that.

People in Egypt vented their grievance through massive protests against Morsi and his government. In many other countries in that part of the world we also see such protests against government many of which often occur with violence. There is no power greater than people power. However, it is effectively achieved not just by demonstrations but by exercise of ballot. You cannot solve a democratic issue through the barrel of the gun or exercise of brute force in a strike. If you want to defeat a political system or philosophy defeat it at the polls. A political commentator rightly remarked on the recent happenings in Egypt, "A military intervention, even one backed by the street, will never achieve the lasting impact of an electoral defeat, and will always leave the impression that those backing the intervention fear that they cannot win an election."

Pakistan cracks down on militants

Pakistan authorities seem to have decided that enough is enough, and it is time to weed out the extremists that have been running a reign of terror so long in its North West corner. The government and its powerful army have drawn a twenty point program to stop the cancer of extremism and religious militancy that in last ten years claimed more than fifty thousand people the last being the most senseless and mindless killing of one hundred fifty children. The steps include creating a para military force to combat the extremists, capital punishment of persons charged with extremist violence, and monitoring and regulating funding sources of the religious institutions. We can only hope that this resolve of Pakistan is for real, and it will not go the way of past such resolves of Pakistan authorities that were more known for the rhetoric than for real action.

One wishes that this will to eradicate the evil that has spawned over the last two decades had descended on Pakistan years ago. This would have saved the country thousands of lives, endless amount of financial resources, and above all the image of an intolerant and bigoted society. Unfortunately, it was not to be so; because the powers that are today declaring war on the militants are the same who had once nurtured them and helped grow the monsters they are today.

Birth of the religious extremists or the jihadists (as they call themselves) in Pakistan is no accident. This was by design, with direct help of the powers that be in Pakistan,

in particular the army that had always been the king maker of the country. The midwife of religious extremism was General Ziaul Huq, the army General who commandeered his way to Presidency and later became the rallying point of the West to wage war against Soviet aggression in Afghanistan. He adroitly used the Western powers reliance on him to wage this war with locally recruited guerilla forces motivating them with Islamic zeal to fight a communist regime. With abundant resources showered on him by the west, Ziaul Huq, himself a firebrand Islamist, created seminaries all over the country that would turn out to be recruitment centers of religious militants who would initially fight the soviets as Mujahids (freedom fighters) but later form the seed for the Taliban forces. The Talibans of Afghanistan were the brain child of Pakistan's formidable Army intelligence, who ironically would later also have a fraternity in Pakistan imbued with similar ideals.

Taliban-Pakistan Army axis would have gone on merrily had this not been for the tragedy of September 11 that exposed the Taliban's shelter to the main perpetrators of the Tragedy. Pakistan authorities had to renounce their liaison with the Taliban under duress and helped support US war in Afghanistan to topple them. But in the change of guards, the Taliban simply blended and scattered all over including slipping into Pakistan where they joined hands with their fellow sympathizers and blood brothers. Although this happened primarily in the territory adjoining Afghanistan, their ideological supporters were spread out

all over Pakistan. And these supporters would also be within the Army and its powerful intelligence branch.

Two powerful examples of such support were the firebrand imam of Islamabad Lal Masjid –Abdul Aziz, and the leader of Pakistan Taliban –Fazlullah. Abdul Aziz, who was a protégé of General Ziaul Huq, preached his bigoted religious philosophy and intolerance day after day for decades, vowing to establish his brand of religious ideals in the country defying the government. He trained his students inside the mosque in handling small arms, and at one stage turned the mosque into a fort when police tried to stop the militant students from attacking them. The mosque would later turn into a battle ground leading to the deaths of many civilians. The fortress of extremist militants that grew under the nose of Pakistan's powerful military intelligence was broken for the time being, but its main leader Abdul Aziz continued to roam free later and preach his violent philosophy.

Fazlullah, a self-declared leader of Pakistani Taliban, similarly grew his forces under the very eyes of Pakistani authorities. With the support of more than 4,500 militants, by late October 2007 Fazlullah had established a "parallel government" in 59 villages in Swat Valley by starting Islamic courts to enforce sharia. For nearly a year he ruled without any nudge from the central authorities. The Pakistan authorities acted only after goading from the US and Fazlullah fled the area. But he continued his recruitment mission of diehard suicide bombers who would wreak havoc in various parts of Pakistan. The latest carnage in Peshawar

that took 150 lives of innocent school children was also reportedly masterminded by him.

There are many other such militant leaders who are heading one or the other faction of Pakistan Taliban including Baitullah Meshud, the self-declared ruler of South Waziristan (reportedly killed recently by US drone attack), Samiul Huq (spiritual guide of Meshud), Sheikh Haqqani (Deputy Leader of Tehrik-e-Taliban), etc. who continue to operate in Pakistan. They have been able to operate and guide their forces under the nose of Pakistan authorities either because the authorities have never shown any seriousness to apprehend them or they connive at their presence. This is also largely because the king makers of Pakistan who created the Frankenstein of religious zealots to start with used them as pawns in the past to change power play in Pakistan suiting their objectives. That is why even though the so called war against terrorism began in Pakistan more than a decade ago never succeeded to weed out the extremists form the soil of the country.

There may be a lot skepticism about this latest phase of war against religious extremism in Pakistan, but one thing is certain; a second failure will not only pave the way for greater uncertainty about stability of Pakistan, but also peace in the sub-continent. What is spawned in Pakistan can affect and will affect the rest of the region. It is in the interest of us all in the region that this time Pakistan means serious business and the country's establishment including the powerful military bring this evil to an end.

Obama and the Middle East

Defying all predictions to the contrary Israel's hawkish Prime Minister has a fourth time chance to be at the helm of his country's government, albeit his party won only a fourth of the Parliamentary seats. If he runs the full next term, he will be the longest serving Prime Minister of Israel after David Ben-Gurion. Political analysts both in the US and in Israel attribute this last minute rebound of Bibi (as Netanyahu is known as) in a tightly fought contest to latest public statements opposing statehood to Palestine, stoking of Israeli fear of a nuclear Iran, and his brazen calls to his supporters to counter Israeli-Arabs voting strength (they consist twenty percent of voting population in Israel). And Netanyahu victory follows closely on the heels of his open criticism of Obama administration's negotiations with Iran on a nuclear deal. He did not stop by voicing his opposition from his country; he also carried the message all the way to Washington and vented his opposition to any such deal in a joint session of the US Congress.

With a razor thin margin of victory over his nearest opposition, Netanyahu may not represent the wishes of all Israeli voters. But in a parliamentary system that allows formation of government by the single largest party with support from likeminded factions, Israel will pursue policies that Netanyahu and his party choose. And these policies will not necessarily be favoring those that Obama

and his administration would like to see in the Middle East. Here is the rub.

Obama and Netanyahu had a tense relationship from the time the former became President of the United States. Unlike his predecessor Obama came to office with a more pacific world view, one that promised withdrawal of forces from Iraq, drawing down on military responses to quell international disputes, and a renewed effort to mitigate Israeli-Palestine hostilities eventually leading to a two-state solution. Not that Obama succeeded in his foreign policy goals, for many of the goals were stymied by several uprising and new wars in the Middle East.

A country's foreign policy is not always dictated by the wishes or choices of its head of state, definitely not the United States. In the US the actors come from many stages, the Congress, the Political parties, and other pressure groups. Notably the pressure groups come from a wide spectrum of politics, corporate interests, lobbies, and the so called Think Tanks. Among foreign countries that have stake in US foreign policy Israel is at the forefront, and no other foreign leader knows better than Netanyahu how to play these different actors. His biggest success in this effort was his invitation by the US Senate to address the joint session early March where he chastised US negotiations with Iran calling these harmful. He also used the podium to court voters in his own country, and apparently he succeeded.

It will be an over statement to say that a Netanyahu victory will pose a stumbling road block for Obama to further his Middle East policy in particular his ongoing nuclear deal with Iran. There are many more imponderables in furthering Obama objectives; the opposition from a Republican dominated Congress being not the least. Obama foreign policy has been faulted by his opposition on many counts including his apparent choice against military intervention in Syria and Ukraine. His latest efforts to reach a nuclear deal with Iran (along five other Western powers) on conditional lifting of economic sanctions against Iran subject to Iran's restriction on nuclear energy uses have been denounced by the hawks in the country. But even then a renewed term for Netanyahu means continuation of a fierce opposition to Obama's overtures to Iran with a substantial domestic support.

Will Obama's foreign policy objectives in the Middle East falter given the prospects of mounting opposition to it home and abroad? Will he shy away from a nuclear deal with Iran, or will his administration give up the hopes of future Israeli-Palestinian negotiations for a peace deal?

Obama has less than two years in office, with no prospects of another term. Netanyahu has four more years. His hopes will be to see any Obama initiatives to fail, and even if they succeed now, these will not be sustained in a future US Presidency from the opposite party. For Obama his success will be if he can pull through his current efforts.

Of the two, the nuclear deal will perhaps go ahead if Iran sticks to its own end of the bargain. The deal may not hold later if a Republican wins the Presidency next time, but for now Obama may see through this despite an unfriendly Congress. Israeli-Palestinian deal for now and foreseeable future will probably be shelved. The Middle East, in the meantime will continue to boil in the cauldron.

Illusions of secularity and reality of communalism

The senseless attack on a minority village in Brahman Baria and destruction of property and a temple there does not reveal any new truth about intolerance and communal side of a certain section of our population in the country. It also does not forebode sudden shift in the population at large toward bigotry and surge in communalism. What it does, however, is to wake us up to the dangers of tolerance of such conduct at political level and the continued existence of the mindset of the religious divide that dominated the country since the time of partition of India. It is a reminder that this this divide was exploited for political purposes in Pakistan for as long we were part of that country and more lamentably, even after the breakup of that country and birth of Bangladesh, once wedded to the principle of secularism.

In the coming days when our political leaders and government agencies probe into this unfortunate happening, like they did after the marauders ransacked a Buddhist village in Ramu, strong words of condemnation will be uttered. Everyone will decry the incident and call for the heads of those who caused this grievous assault. In fact, it is most likely that some small time criminals and hired goons who probably took part in this riot will be found, brought to justice, and attempts will be made to assure the minority community that there will be no repeat of such heinous acts. Life will again turn to normal for some time,

until another incident of similar kind happens in a different area of the country.

I say this rather shamefacedly because Brahman Baria incident is not unique in our country. It has happened before, may be not in such massive form against a whole village, but against individuals belonging to the minority community. These murders, majority of which occurred in last four years, were explained away as handiwork of a politically committed group determined to undermine and embarrass the government in public and foreign eyes. Although none, or a very few of these murders have been solved, people accepted these as targeted attacks which were not necessarily against a whole community. However, these explanations are not enough to assure the minority community as a whole for their safety in a country that has a long history of communal turbulence from time to time.

The recurrence of such incidents despite our government's apparent effort to prevent these and prevalence of communal good feeling in the majority of our people has to do with a number of facts. These are, not necessarily in the order of priority, growth of religious intolerance, suspicion of secularism as absence of religion, exploitation of religion for political purposes, and resurgence of political Islam in the country and its committed followers. Bangladesh is not alone in the first two; in India there has been a gradual corrosion of religious intolerance, notably since the rise of BJP and stranglehold of politics by extreme rightist elements there. Secularism is under threat in India as

these elements appear to force government to accept their religiously biased demands time to time.

Unlike India we cannot say that secularism is threatened in Bangladesh because we effectively deleted that concept, one of the four founding principles of our first constitution, when the military usurpers of government in our country declared Islam as the state religion. The current government has tried to scotch tape that amendment by reinsertion of secularism in the constitution but without changing the part that gives the country a state religion. Ostensibly, the state religion has been retained not to ignite or provoke the majority community of the country; without regard to the effect such constitutional status given to one religion will have on the minority community.

This brings to my mind the historic speech given by Shrish Chandra Chattopadhyay, then leader of the opposition (Congress member from then East Bengal) in the Constituent Assembly of Pakistan after the introduction of the Objectives Resolution by then Prime Minister Liaqat Ali Khan. The Objectives Resolution had brought into discussion the course of action that the country should follow to establish its laws in accordance with the Quran and Sunnah. Criticizing it in the constituent assembly Chattopadhyay said on 12 March 1949:

"In my conception of state where people of different religion live there is no place for religion in the state. Its position must be neutral: no bias for any religion. If necessary, it should

help all the religions equally. No question of concession or tolerance to any religion. It smacks of inferiority complex. The state must respect all religions: no smiling face for one and askance look to the other. The state religion is a dangerous principle".

It is remarkable that in less than twenty five years of this resolution the eastern part of Pakistan would break away to form a country based on principles articulated by Chattopadhyay. The birth of Bangladesh based on a concept of linguistic and cultural nationhood broke away from the concept of nationhood based on religion. However, the divide between communities was never completely gone from the psyche of many people. This is why we see recurrence of the transgressions of the kind seen in Brahman Baria and other places in the country.

In the same speech referred to above Shrish Chandra Chattopadhyay had said while referring to the Hindu Minority community of then East Bengal (about 25% that time):

"But we belong to East Bengal. One-fourth of the population is still non-Muslim…We are not going to leave East Bengal. It is our homeland. It is not a land by our adoption….. East Bengal is my land. I claim that East Bengal and Eastern Pakistan belongs to me as well as to any Mussalman and it will be my duty to make Pakistan a great, prosperous and powerful State so that it may get a proper place in the comity of nations because I call myself a Pakistani. I

wish that Pakistan must be a great State…..We are living in East Bengal peacefully, in peace and amity without Muslim neighbors as we had been living from generations to generations. Therefore, I am anxious to see that its constitution is framed in such a way which may suit the Muslims as well as the non-Muslims".

Had Shrish Chandra been alive today, he would have perhaps repeated his words, albeit in a different context. But his message would have been the same. Bangladesh, once East Pakistan and East Bengal, had been home to both Muslims and Hindus (as well as other minorities) for centuries. They have lived together as peaceful communities, and despite political manipulation and resurgence of communalism from time to time, Bangladesh belongs to all communities. But it is one thing to talk of religious equality and impartiality and another to live it.

Our government and political leaders cannot fulfil their obligation only by reacting to crisis, but by creating conditions of safety and security in the mind of all. This cannot be achieved simply by catching the culprits, but by reinforcing religious equality and impartiality in our laws, the principle that the founding fathers of our constitution believed in.

Coddling Religious Extremists for Political Gains

The headlines hitting the news media recently in Pakistan and elsewhere have put a hitherto unknown Lal Masjid- a mosque and seminary in Islamabad and its denizens in the world map. The horrific incidents surrounding the mosque and the resulting mayhem are an object lesson how things can go awry with disastrous results when government coddles religious elements and religious institutions either for political reasons, or for fear of public backlash.

The Lal Masjid is a seminary that provides religious education based on Deobond curriculum to about 7,000 students studying in the male and female sections.

The mosque constructed and funded by the Pakistan government was originally the main mosque in Islamabad patronized by government officials including top army brass. Its central location placed it within close proximity of various government offices, the ISI among them. A senior government official originally served as the Imam of the mosque. But that was Pakistan before the incursion of religious extremism into Pakistan politics led by General Ziaul Huq.

With General Ziaul Huq leading the country in the heady days of US assisted fight against the Russians in Afghanistan, the Lal Masjid turned into a madrassa, training students who would be cannon fodders for the holy war. This happened during the time when Abdullah, the

father of the current Lal Masjid imam Abdul Aziz, was the Mosque prayer leader. General Ziaul Huq was reportedly a great admirer of Abdullah who was known for his fiery "jihadi" speeches.

Abdul Aziz succeeded his father as the Imam of Lal Masjid after the demise of Abdullah in a sectarian strife in 1990 or thereabout. Trained in a renowned madrassa in Karachi, and having worked closely with the Afghan mujahidin's that his father's madrassa had trained both Abdul Aziz and his brother Abdur Rashid became firebrand radicals who would later use the Lal Masjid to train young minds in their school of thought. However, the clash with government would not occur until much later. Abdul Aziz, his brother, and his wife would carry on their agenda under the very nose of ISI.

The first brush with the government occurred in 2005 when Abdul Aziz issued a fatwa against the army officers who were fighting against Pakistani Taliban in the tribal areas close to the Afghan border. For this reason he was dismissed from his mosque position by the government, but he refused to vacate the mosque. With his baton wielding acolytes (men and women) in the madrassa he turned the mosque and the adjoining seminary into a fortress daring any law enforcing agency to oust him. The government relented.

Next came protests by the madrassa students against the government campaign to demolish illegally constructed

mosques in Islamabad. They followed these protests along with their teachers threatening the owners of video and music shops in Islamabad to close down their business or face dire consequences. The female students of the seminary assisted by the male students raided an alleged brothel house, kidnapped three women from there and held them hostage for three days before releasing them after securing confessional statements saying that there were involved in "immoral activities". All this happened under the watchful eyes of Pakistani and international media.

The most egregious of the unlawful activities was, however, when the students and their teachers abducted three policemen when they went about their duties in search of students who were breaking law. This time also the government relented. Instead of carrying out any massive attack the police negotiated the release of the three policemen. Another victory for the radicals and their leader.

It took several months for the Pakistan Government to realize that it was time to take the bull by the horn. The demon it was nurturing close to its core was giving birth to hundreds of radicals who were being shipped to fight its army and botch its war on terrorism from within. Ironically, it was fighting the very elements that were born out of direct government subsidy, and later of sheer neglect. At the time of this writing, the siege of the mosque is still on with uncertain outcome. Still, the action taken now is far better than later when the radicals bred by the seminary

would have spread much wider preaching and practicing their violence all over the country to implement their goals.

Is there a lesson to be learnt from all this? Use of religion for short term political gains is not unknown – at least that we know from the history of Pakistan and Bangladesh. In the 60s Ayub Khan gathered the support of the ulema for his regime. General Ziaul Huq not only indulged in the religious elements, but considered himself as the new messiah. Pakistan is still reaping the harvest of the seeds that he had sown. In Bangladesh, in the early seventies General Zia was blessed in a national gathering of the Mudarreseen (Association of Madrassa teachers). Later, we saw the repetition of the blessing of the dictatorship of General Ershad by the same elements.

Ironically where the military leaders had stopped short of embracing the religious elements as their political partners, the political leaders who followed the military dictators sought them as allies to spurn their opponents. This dangerous gambit of political opportunism supported later the growth of the kind of religious extremism that we would see later with shock and disbelief. We came out this time with a low price for this political shenanigan, but we may not be so lucky the next time around.

Our political party leaders often speak of conspiracies against our democracy. Few of them seem to realize that these conspiracies do not come from without, but from within the party. These come from their inability to

recognize that forces that seek to usurp state power with violent means first work silently with connivance of allies that they set up in powerful quarters. We need be watchful that Lal Masjid experience does not repeat elsewhere.

The Elephant in the Room and Our Denial Syndrome

Bangladesh Home Minister has denied again the presence of foreign hands in the militancy that has been raging in the country over last two years or so. He and his colleagues have been consistent in this regard. They think all militancy related activities in the country that include twenty killings in Gulshan and many others before and after this incident have been perpetrated by domestic terrorists with a local agenda. Their assertions fly in the face of overwhelming evidence of presence of globally inspired terrorism in the country that includes videos of call to Jihad by people of Bangladeshi origin purported to have been made in ISIS controlled territory in Syria. This is beside claims of ownership of acts of terrorism in the country by followers of that militant outfit.

The repeated denials by some of our people in authority of any foreign linkage of recent acts of terror and terrorists are an in your face rebuttal of legion of reports from foreign press and intelligence agencies (including that of US) of the overarching reach of Islamic Militants. This is an outreach that transgresses international borders, and are making new associates wherever possible, Bangladesh included. Most recently, while talking about the global reach of ISIS President Obama referred to Bangladesh as one of the countries that ISIS has attacked. He said this in the context of US effort s to defeat the militant organization remarking

that the organization will continue to inspire if not directly conduct its terror attacks in other countries even as though it may lose its stronghold in Syria.

We wish our government leaders were right, and the acts of terrorism shaking the country today were all handiwork of local hoodlums recruited by political parties out to harass the government and destabilize the country. We wish the mastermind of the tragic and horrific happenings of Gulshan, Sholakia, and murders of Hindu priests and other foreigners were truly a local thug, and he and his group of criminals would be apprehended soon. We wish this could bring an end to this violence.

Unfortunately this is not so. The reality is far from this simple assumption or declaration. The genesis of violence of Gulshan or Sholakia did not begin with these two places, nor did it begin with the perpetrators of the incidents in two places. The genesis has to do with the blindfold that we have been wearing for years denying existence or possibility of spread of radicalism in the country by people who have been indoctrinated by an ideology that has attracted hundreds of thousands before them in different parts of the world. This blindfold which our leaders have been wearing either unwittingly or on purpose distracted our government from combating radicalism and extremists, and instead directed its attention toward suppressing political opponents by blaming them for the acts of terror.

Only two months before the terrible happening in Gulshan the Government had launched a countrywide strike against terrorism leading to arrests of thousands of so called suspects all over the country very few of whom had any known ties with any militant group. Ironically, the tragic event happened and nearly two dozen innocent people perished in an apparently high-security residential neighborhood after thousands of "suspected terrorists" were put away in jail. It may take years and months for our government to find out the why and how of these terror acts, but the simple fact remains that all of these were possible because we have been denying the possibility of a global hand in indoctrinating our youths in such radical ideologies and acts. As in the past where previous government adamantly refused to accept presence and growth of foreign inspired terrorism in Bangladesh and blamed the opposition for causing instability through hired hands, we are witnessing a repeat of the same story with fresh attacks despite evidences of foreign hands and foreign inspiration.

The perpetrators of terrorism and violence in Bangladesh may be all Bangladeshis, and some of them may perhaps belong to home grown militant organizations. But their ideology and inspiration are not necessarily rooted in domestic political goals. The ideology that ISIS spreads attracts youths all across the Globe, youths of all descriptions, from marginalized societies in foreign countries, disgruntled and economically deprived parts, and as we are seeing in Bangladesh, youths from economically well off and well to do societies. Like the radicals in the Middle East, and

other parts of Europe or USA, the people embracing the extremist ideology in Bangladesh have shown the same level of attraction or loyalty to this overarching militant entity, be it a romantic idea of establishing an Islamic State or carrying out a distorted vision of Jihad. The point is that the surfeit that is affecting Bangladesh is not endemic, it is an epidemic that has spread globally and we need to address it accordingly. Our leaders should come out of their fear to make the call they need to combat this crisis properly.

It is said that crisis always presents opportunities for change. But these changes should be for the better not worse. The crisis that Bangladesh faces today is not only a threat to internal security and safety of our people; it is also a serious threat to our economic growth, business and future investment. The more we deny the real threat and refuse to see the sources of the threat the more danger we expose our people to the threat. We may dismantle all the unauthorized business and educational establishments in the city, we may continue to round up the usual suspects for terrorism all over the country, but we will continue to have the elephant in the room unless we are prepared to face it. We have to find out and terminate foreign connections to terrorism in the country, and stop our youths from getting ensnared by the foreign groups. And for this Bangladesh should seek help from all.

Compromises of Disaster

As I write this piece the Pakistan Army is still engaged in a war that aims to cleanse Swat of the religious extremists who had laid claim to one of the most picturesque areas of the world for the better part of last two years. The place, as it appears from hundreds of pictures published in various media, has been rendered into a horrendous battle scene with battered homes, and other devastations all around. Thousands of innocent civilians have been forced to flee the battlegrounds for uncertain destinations beyond their picturesque valley, while the army tries to ferret out the militants and their ferocious leaders from the mountainous areas.

Now in a final attempt to maim and decimate the Swat militants, the Pakistan Government has announced a bounty of fifty millions rupees ($600,000) on the head of its most fearsome leader, Maulana Fazlullah. Readers will recall that this was the man notorious for his sermons that denounced Pakistan Government as un-Islamic and called for establishing his version of Sharia in the valley. This was the leader whose disciples flogged a young girl in open public view for alleged behavior unbecoming a Muslim woman. This was the cleric who condemned music as evil, and asked his followers to burn shops that sold TVs, CDs, and computers since these were "major sources of sin". Yet, this was the man with whom the Government of Pakistan negotiated and compromised with only a few months

earlier to cede the place to Sharia court at his behest. The compromise with one of the most iconic leaders of religious extremism was yet another example of fecklessness that had characterized the government of Pakistan's response to religious extremism that had been overtaking that part of the country for past several years.

Our attention would be riveted toward Pakistan as it launches its latest efforts to uproot the religious extremists from Swat, and rid the area of its fearsome warlord and his disciples who had led to such horrendous events in that area. We will be eagerly awaiting the results.

Unfortunately, however, Maulana Fazlullah is but one of the many such diabolical clerics who had grown and was tolerated in those parts in last several years either because of government apathy or coddling for short term political gains. Maulana Abdul Aziz, the firebrand cleric of Lal Masjid of Islamabad, whose actions finally led to a bloody mayhem in and around that mosque two years back, is another product of political compromise. This bigoted cleric had converted his mosque into a seminary of "holy warriors" or "jihadis", all within a square mile of the highest seat of government power in Pakistan, had preached his violent sermons in the presence of high government officials, civil and military, and the government had turned the other way. It was not until his disciples actually launched an attack against the police and the army that government took upon him, like the actions against Maulana Fazlullah that the government

of Pakistan is taking now. That action too was too late, with disastrous consequences.

Many in Bangladesh thought for years that we were immune from the poison that was slowly numbing Pakistan, as if our physical distance from that country worked as a firewall. We dismissed even a suggestion of the proclivity of some of our own citizens to tend the way of Pakistan clerics, even though the signs became too apparent to ignore such suggestion. This was the mindset of our political leaders few years ago, until the phenomenon of "Bangla Bhai" would demonstrate to us that in the tryst with religious extremism he was no less a formidable figure than his Pakistan counterparts. Again, the final grappling with this nemesis of ours, albeit transient, would not happen until much damage had been done to life and property. This needless loss could have been avoided if our political leadership that time had not sought to use this force, however locally, to settle political scores. Rise of elements like Bangla Bhai and his ilk was possible because our leadership chose the path of compromise, political expediency, and use of means fair and foul to retain political control.

Fortunately there seems to be a tide of events that is opening our eyes to the dangers of coddling religious extremists and the consequences of giving indulgence to such fanaticism for short term gains. In Pakistan this had been possible as military dictators found support for their hold on to power from these radical elements. The leadership used them, and

in return for their support gave them a long leash, which unfortunately later proved to be their undoing.

Ironically in Bangladesh the radical elements grew and survived when a democratically elected government ruled the roost. They were the by-products of an alliance of political convenience the main goal of which was to countenance the country's progress in establishing a moderate, religiously tolerant, democratic country. They flourished because they were not challenged, or as we would recall their existence was even denied by some leaders that time. It would take several killings, and of course much external pressure on our leaders that time to arrest the growth of these elements. And actually we do not know if justice would have come at all to wind up some of these elements, including Bangla Bhai, had there not been a new government.

We are exposed daily now to new revelations from the national press about the shenanigans that were in play in the infamous arms smuggling in Chittagong. If true, these would be reminders how deep a nexus of radicals can work, and the level of danger that a nation could be dragged to when the political leadership looks the other way. The point of raising these incendiary issues is really to bring home the need for realization for our political leaders that a line has to be drawn in all politics that separates democracy from bigotry, hatred and violence from free speech, and love for humanity from obsession with religion. We hope we call can remember these.

Sowing Wild Oats of Religious Militancy

Almost every week these days we find in the news reports of arrests made by police of elements that are associated with religious militancy. Some of them have been in the wanted list for having direct connections to acts of assassination or other destruction, some for suspicion of connection with militant organizations and bodies. This should not surprise us as for long we had nurtured these elements, even coddled them for short term political gains. I say short term with some hesitation, as I am not fully convinced that among some of the political patrons of there are elements who do not indulge long term goals of establishing an alternative system of governance in the country. Nevertheless, we should be thankful that there is now a genuine effort in containing the radical forces that were set loose in an earlier period.

What should concern us, however, is the presence of a mindset among our political leaders that could be opposed to building a society that is free from religious bigotry, intolerance of religious and political differences, and violent imposition of religious doctrines. History is a witness that profession of this school of thought had led to acrimonious debates within the community, and ultimately to civil wars.

Within a few years of our hard fought independence we saw a premature demise of the ideals of secularism, and dream of a pluralistic society built on the beliefs and cultures of multiple faiths. We had witnessed contemptible attempts

to denigrate our nationhood based on our language and culture, in favor of religious identity alone that was mightily unsuccessful in keeping us wedded to a geographically dispersed entity before.

Unfortunately, these malignant forces, contrary to the values for which we fought, did not take birth in a vacuum. They have been always present with both internal and external help.

Internally these forces have been sustained by elements that had always aligned themselves to a political ideology based on religion alone. These elements were dormant in the initial years of our independence, but were stoked back into life after the founder of our nation was cruelly struck down. People who date back to the early seventies will remember that among the first to embrace General Ziaur Rahman as the savior of the country were the leaders of the Madrassa Board and other religious organizations that were practically defunct immediately after the independence.

Externally, the forces have been aided and abetted by the proselytizers of a political philosophy that seeks a forced imposition of religious dogma on our life and politics. A principal way to propagate this ideology has been through financing of institutions for religious education, and religious charities. The prime example being the exponential growth in private madrassas in the country in last two decades, and the upsurge in religious charities (NGOs) that have little audit of the sources of their funds. In the case of

Bangladesh, however, one of the ways the seeds of external encroachment to guide and assist the radical forces were sown from across our eastern border.

I believe the foot in the door for the global network to proselytize the radical version of religion was made possible in our country by the first influx of the Rohingya Muslims from Arakans in Burma (now Myanmar) to Bangladesh in 1978. As Deputy Commissioner of Chittagong that period I was on the receiving end of the influx and had toiled over months with my colleagues to provide food and shelter to hundreds of thousands of men, women, and children. In the first week of this exodus about ten to twenty thousand refugees arrived all of whom were accommodated with local help in schools, cyclone shelters, and make shift tents. However, as time passed and more and more shelters were established along the Burma border after international agencies got in to help, the number of refugees sweltered to around two hundred thousand.

Our initial thinking, when the first wave of refugees arrived in the borders in tattered clothes, was that they were victims of a brutal ethnic cleansing effort launched by a junta. The refugees claimed that they were driven out of their villages by marauding Burmese army intent upon killing all "Muslims". I had no idea until that time Arakans had a substantial Muslim population. However, the stories given out by the refugees were not consistent. While a good number stated that they were hounded by the army for their religion, some others stated it was because of their

ethnicity. The only consistent story was that that they had left behind their hearth and homes out of some fear. The ethnicity part appeared more credible to me as the refugees were of Bengali origin, a large number of who had actually migrated to Burma only a generation before. Moreover, the claims by the Burmese authority that period were that these refugees were mostly illegal, and the effort of the government was only directed against the illegal citizens only.

In the midst of these conflicting stories about the reasons for the mass exodus of the Arakan Muslims I received some astounding information from a traveling journalist of the Far Eastern Economic Review (now defunct) on these events. The journalist, a British reporter, was visiting the area like many other international journalists who came to witness and report on the mass migration. While interviewing me, the journalist stated that the he had visited the Burmese side before coming to Chittagong where he had interviewed the main leaders of the Rohingya "guerillas". I was struck to no end by hearing the word "guerillas" as I had assumed like many others, both within and outside our country, that the refugees were hapless victims of a brutal ethnic cleansing. I was to further learn first time about Rohingya Land for Muslims in the Arakan state that the guerillas stood for. He further informed me that although many refugees had fled Arakan to escape the immigration check by the Burmese authorities (called Operation Nagamin), a large number had been persuaded to leave by the Rohingya Liberation Front (aka Rohingya Solidarity Organization), the main guerila

organization that time. I found the information so alarming, but useful at the same time, that I alerted our government to this additional dimension to our mounting refugee problem.

The new information notwithstanding, we could not stop the wave of refugees crossing daily our eastern border, and we could not help but continue to shelter them. Our law enforcing authorities had no way to verify who among these refugees were actual guerillas as none carried any weapons, at least openly. The involvement of UNHCR and other international aid agencies also made it difficult for us to discriminate based on suspicions of affiliation of any of the refugees with any armed guerilla group. Our government's intention that time was not escalate the problem to international level, but to repatriate the refugees negotiating with Burma, in which we succeeded.

With the number of refugees growing every day the government allowed more and more foreign organizations to come forward with assistance, including Rabita al-Alam al-Islami, a religious charity based in Saudi Arabia. The nexus of the Rohingya guerillas with our own radical elements first came to my attention when the Sub divisional Officer of Cox's Bazar stated that he had received an application for lease of government land in Ukhiya (a thana bordering Burma where the majority of the refugees were camped). The lease requested was for establishment of a mosque and hospital with financing from Rabita al Alam al Islami. Since the charity organization was foreign, the application for lease was made by a local resident. Normally this would not

pose a problem since the sponsor was a known International Charity Organization. But the problem was the applicant who according our records who had been an active member of the student wing of Jamat-e-Islami, which that time was a banned organization. The applicant was prosecuted under the Collaborator Ordinance, but unfortunately the case was dropped along with others when the general amnesty was proclaimed by Bangabandhu. Nonetheless I had no hesitation to ask the SDO to reject the application knowing about the applicant's identity. I knew also well that there would be consequences to this decision.

There were consequences. The applicant had friends in higher places, particularly in the Ministry of Home Affairs that period, who asked the SDO the reasons for denial. The ball finally rolled to my court, and I had to defend our decision citing serious local opposition to the applicant who was still remembered in the area for his criminal role during the war of liberation. I believe the matter went up to President Zia who for reasons best known to him did not want to pursue the case of the collaborator, at least till he was alive. I say till he was alive because shortly after the takeover of the government by General Ershad, permission was given to the same person and his allies to establish the Hospital and Religious Center in Ukhiya under Rabita banner. A center was established right across our border that would provide relief and support to a militant organization that was fighting an ongoing battle with their own government.

Unfortunately it would take us more than a decade to realize to our peril that in the wake of showing our hospitality to the Rohingya refugees we had also invited a group of militants who would be allies to radical extremists in our country. Reportedly, the Rohingya movement not only fed arms to our militants but provided a fertile ground of recruitment of religious militants worldwide as far as Afghanistan and Bosnia.

If last several years experiences are any lesson we should do well to follow the trails of destruction and hound out all elements, past, present, and future to weed out the threat of militancy that our country had been exposed to. There have been some laudable actions in the last two years. The most salient features of these had been arrest, prosecution, and meting out of exemplary punishment to some of these radical elements. But the looming fear is that with the continued mind set in some of our political leaders to gain support from these elements for political power we may fall back to these hands and expose our society, and country at large to possible anarchy.

My fear is because we have yet to identify and unearth the real forces that were behind the arms smuggling of Chittagong because of the unseen political hands that prop the radical elements. My fear of the resurgence of the radical forces grows when I still see that some of our political leaders are out to muddy the prosecution of the war criminals on pretext of political opposition to the party in power. All I can hope is that our leaders rise above their

narrow goal of short term political alliance with a force that we all know does not believe in a pluralistic society or liberal democracy, ideals that we want our nation to be built upon.

The Roar of the Radicals

The disturbing happenings in Baitul Mukarram Masjid square of April 11 are a stark reminder to all of us that the specter of religious extremism continues to hang over our head like the proverbial sword of Damocles. It is a serious threat to our social fabric unless we deal with it firmly now. Thanks to wide media coverage, a worldwide audience watched with awe video footages of hirsute young men in white robes chasing police armed with sticks, and hurling missiles of bricks and stones that were presumably stored near the mosque. Few people who watched this encounter from abroad had any knowledge what led these people to such violent encounter; but they saw with their own eyes who they were, and that they were challenging armed law enforcers to a show of strength.

This may sound a bit over dramatic, but to underscore a point I must say that to some of us the incident at Baitul Mukarram brought back uncomfortable flashes of the Lal Masjid incidents of Pakistan last year. True, the Lal Masjid had ultimately turned into a war zone with disastrous and murderous consequences. But we must remember that the forces that had challenged the law enforcing agencies of Pakistan from that center originally started their crusade against the authorities with sticks and stones, and ended up with machine guns. And we must also remember that like the Baitul Mukarram mosque, the Lal Masjid was also a government owned religious institution.

To explain away the April 11 incident as another instance of bigotry by a small group of fanatics is a cop out. This was not an impulsive act by a group of people misled by any propaganda that hurt their religious feelings. This was not a spur of the moment protest against any political rhetoric. This was a planned incident orchestrated by people who want to impose their interpretation of religion on others, and along with it their political ideology.

I say this because there has been a pattern of behavior of a section in our country in last few weeks over a putative legislation concerning women's property rights. This started with noise by this section that it was beyond the government's legal power (*ultra vires*) to have a policy that allows equal rights to women since it would go against religion. The noise was followed by public utterances and protests by some people following that line of thought that such actions would violate religious dictates on the subject. No one cared to explain how a policy espousing equality of human rights, men and women, would militate against our religion. These utterances went unchallenged since we, the educated majority have delegated the responsibility of interpreting religion to the clerics. The culmination of this silence was the April 11 incident.

Our worries and concerns would have been minimal, had the efforts of this school of thought been limited to interpretation of religion only for religious purposes. Unfortunately, these clerics, products of largely unchecked religious institutions, not only act as guardians of the

religion, but they now want to ensure that our legislative agenda also carry their seal of approval.

To me the implications of this incident are far wider than the protest over an issue of legislation that may have "religious" connotation to a group of people. Although in minority, this school of thought is rarely challenged as most of us tend to shy away from topics that touch religion. Our political leaders in the past either avoided these issues, or embraced the proponents of this line of thought as political partners for short term gains. Our reluctance to deal with topics of religious sensitivity through public debates, and often coddling of some leaders of this radical line of thinking have made this section of people take lead on these issues and insinuate themselves in formulation of public policies in the name of religion.

The Lal Masjid happenings of Pakistan taught us that religious militancy can grow at one's door step when state power nurtures radical elements either through negligence or for short term political gains. It has shown how radicals can proliferate at state expense when young minds are tutored and trained to implement radical ideologies with wrong interpretation of religion.

There are two parts to tackling any looming threat of religious extremism. One is treating it as another law and order concern; and the other is treating it as a potential threat to our goal to establish a pluralistic and democratic society. A law and order concern is addressed when the law

breakers are contained and order restored. But a potential threat by religious radicals cannot be stopped by simply police actions. This needs first a full awareness of the potential threat, an acknowledgment by all that it exists, and engagement of all righteous sections of our society in opposing such ideas and ideology.

Tackling Religious Militancy

The Government of Pakistan has recently come down with a heavy hand on several of the country's religious organizations on charges of breeding terrorism in the name of religion. The offices and several hundred educational institutions or Madrassas, run by these organizations have been sealed, banned and the organization themselves outlawed. The Pakistani agency in charge of the operation claimed that the organizations were extremist outfits; in the name of religious education the seminaries run by them were busy producing militants. It is ironic that a decade ago a different government agency of the same country was itself helping some of these organizations to produce the very elements that the government is now trying to snuff. But that is a different story. Important thing is that the government of Pakistan has awakened to combat the breeding grounds of religious militancy and the threat it poses to the country's political stability.

Not too long ago in Bangladesh police had discovered explosives and other items unconnected to "religion" in several Madrassas in the country. I have also seen news reports very recently associating Madrassas run by some religious organizations with training of militants. I am not aware if these reports are getting the attention of the quarters that need to be mindful of these activities, and be wary of their consequences to the government, and the country at large—not to speak of the international repercussions. It is

also possible that we are still at denial and are continuing to delude ourselves that a "moderate" country such as ours does not have any extremist groups among us. May be we do not want to find out if there is a tumor in our body politic for fear that it will tarnish our image of good health; for fear of the surgery that we may need to remove the tumor.

Pakistan's government has gone out on a limb, politically that is, to tackle its international reputation of allowing religious militancy fomented by its religious schools. It is everyone's knowledge that majority of the redoubtable Taliban leadership was trained and educated in the seminaries of Pakistan frontiers. Critics may argue that the counter measures taken by Pakistan now to control this militancy result from foreign pressure. But this argument ignores the fact that a government of a predominantly Muslim country could not have taken such bold measures to ban and outlaw religious organizations unless they were seen as pernicious not only by the government, but also by the silent majority. May be these actions should have come sooner; but at least the government is now acting.

I do not know if actions would be taken in our country to identify and isolate religious organizations that subscribe to the principles of the types in Pakistan. The sole objectives of these institutions are to enlist and train impressionable youths for religious militancy with a long-term view of destabilizing the country and ushering in government of their choice—one run by religious bigots that we saw in

Afghanistan. If we think that we are nowhere near Pakistan was or is now, we may need to rethink the potentiality.

Madrassas in Pakistan accounted for about 10% of the school going population in 2002. In the same year the Bangladesh religious system represented approximately 15% of the total school going population (primary through higher secondary). While the student statistics by themselves may not indicate that we in Bangladesh are a notch higher than Pakistan in religious zealotry, we cannot ignore the potentiality of misuse of this vast youth population when trained in the wrong institutions.

Thanks to the Talibans and the western press reports that followed their ascendancy and fall later, Madrassas in the western eye came to be associated with training in militancy. No one has ever gone back in history to say that original Madrassas were set up in the Abbasid period (Golden Age of Islam) for pursuit of rational sciences, and that *Ijtihad* or independent reasoning was a special feature of these institutions. With demise of Muslim ascendancy in science and literature, and rise of orthodox Islam the road of *Ijtihad* was closed. The radical trends gave birth to religious schools founded on teachings exclusively focused on Koranic teachings. In the subcontinent, the impact was even worse. The Madrassa system here took upon itself opposing the western culture and education imposed by the British. The British tried and imposed some changes in the curricula through government sponsored Madrassas; but the vast majority of the seminaries were guided by the

syllabus created in the seminary at Deoband, India, an institution started in 1867 that continues to influence most Madrassas in the subcontinent even today.

The obscurantist syllabus promoted by Deoband made Koran and Hadith the focal points of learning, with emphasis on proper understanding of the tenets of Islam including Shariah laws. Majority of the private Madrassas in Pakistan and Bangladesh today follow the Deoband syllabus (in Bangladesh these institutions are called Quomi Madrassas). Modern sciences are not taught. The preferred languages are Arabic, Persian and Urdu. In addition, many of these Madrassas teach Islamic behavior as opposed to modernity as the only accepted form of conduct for a Muslim. This finally led to indoctrination of the students, particularly in Pakistan, against western culture, and western domination.

The founder of the Deoband school (Maulana Thanvi) scrupulously avoided associating politics with his religious movement, which he started for spreading proper knowledge of the tenets of Islam. Ironically, however, some 130 years later many of the schools inspired by Deoband would not only indulge in politics, but also train a cadre of Mujahedeen who would be called upon to wage war or 'Jihad' against the 'infidels'. Culmination of this training would be creation of the Talibans who would take over Afghanistan.

According to analysts the main reason why there was enormous growth of religious schools or Madrassas in Pakistan was the failure of the government to provide

enough secular schools to accommodate a fast growing population. Madrassas filled in where the secular system failed. They even became more attractive with their relatively less formal structure, easier access, and cost-free education. Their call to serve the cause of religion would make inroads into the heart and minds of rural millions. There is no need for further analysis to draw a parallel of the Pakistan experience to Bangladesh. Situations are similar, and the lot of the village population in two countries is fairly close. What is different, however, is the will to recognize the potentiality of exploitation of these institutions by politically motivated organizations for lethal purposes. In Pakistan, they have recognized it.

Most Madrassas in Bangladesh are perhaps way removed from becoming launching pads of religious militants. But Pakistan experience presents a unique example of how things can go wrong if the religious education system is not monitored properly. There have to be effective ways to regulate flow of funds, monitor syllabus, and to control spread of hatred and deleterious politics from these institutions. To prevent Pakistan experience, several actions are needed. One, recognition at all levels, particularly at the top, that an unmonitored and unregulated religious education system has the potential of breeding radicals. Two, institutions and organizations that promote terrorism or militancy need to be identified, and isolated. Three, strong deterrent measures need to be taken against any sign of militancy or bigotry in the name of religion. It is never too late to take actions.

US Missile Strike in Syria—Simply a Pin Prick?

Ziauddin Choudhury

Nearly five years after the brutal civil war that has destroyed many cities and uprooted millions from their homes in Syria the United States struck a Syrian airbase this week for the first time as a warning to the regime. The strike with missiles from US Navy ships in the Mediterranean were targeted at the airbase that was reportedly used by planes of Assad regime to drop chemical bombs on a town held by rebel forces with horrific results. The chemical bombs that reportedly carried nerve gas killed scores of people and injured hundreds including very small children. The horrible images of death and destruction shocked the entire world, including even President Trump who had dithered during his Presidential campaign on the question of helping Syrians in their plight, not to speak of removing President Assad's brutal regime.

US position in the current civil war in Syria has been ambivalent at best since the war began. President Obama had once pledged to a decisive response to Syrian Government actions against its own citizens if it crossed a "red line". That red line meant Assad regime's taking recourse to use of chemical weapons, which the regime was reportedly having a stock pile of. Unfortunately Obama's much declared threat of use of any deterrent action did not

materialize even after proof of use of such deadly weapons by the regime in 2013 to fight the rebels.

There were many reasons why US did not act on its threat that period. The most tangible was the reluctance of US Congress to approve a military action against Syria, an excuse the Obama administration used for not attacking Syria. There were other cogent reasons too which included rise of Islamic militancy among some rebel groups (which finally gave birth to ISIS), and lack of agreement with Russia in regime change as the Russians were among the backers of Assad regime.

President Obama's reluctance to engage the US in another war in the Middle East by not entering into a military commitment in Syrian civil war and refraining from more direct attack on ISIS was interpreted by his Republican opponents as US withdrawal from leadership. The Republican Presidential candidates, particularly Donald Trump, used every opportunity to deride the Obama Presidency and Trump assured his supporters that if elected he would intervene with military force to strike Islamic militants in Syria and other places.

As things turned out President Trump's agenda in the Middle East got buried in the first few weeks with a quite a few fiascos. Principal among these were the failure to enact a new health care policy that he had promised to replace the policy under Obama. But the biggest distraction was and still is the FBI investigation into suspicious communication

between his staff and Russian Officials during and immediately after the Presidential election. The Russian connection has already cost Trump to lose one of his first cabinet appointees, Michael Flynn, who resigned three weeks after his appointment as National Security Officer. The FBI is still continuing its investigation as also the Senate into alleged involvement of Russia in manipulating US Presidential election campaign.

US missile strike in Syria comes not only in the back drop of the horrific nerve gas attack on the civilians by Assad regime, but also during a time when the media and people in the US are eagerly following the FBI and Senate investigation into Russian interference in US election and its possible nexus with Trump campaign staff.

The question now is how serious is the US response to Assad regime's use of chemical weapons on its people. Is it only a one-time show of US disapproval of the incident or there will be further show of strength to bring down the Assad regime? During his Presidential campaign Trump had shown no interest in the toppling of the regime; his opprobrium was against the Islamic militants who he promised he will destroy. In fact given that Russia, in particular President Putin, the main backer and ally or Assad regime was viewed by Trump as a friend, it would seem odd if Trump were to seek dislodging of Assad as a goal for him. Therefore, everyone watching Trump as well as his views was surprised that he would order a missile strike against Syria even though this pleased many as a

suitable US response. But his action has also raised the logical question of what next.

Experts who have followed the Syrian civil war and its intractability (that is made more complex daily with a host of players in it) opine that a single strike of missiles in a Syrian air base is not likely to dislodge Assad regime from its position. Air strikes and drone attacks over last two and a half years have not eradicated ISIS from its stronghold even though in reality ISIS is not a fully formed state. In contrast the current regime in Syria is the legally (by its own constitution) and formally formed government of Syria. It is still fully dominated by Assad and his supporters. The regime may have been decimated, but it is still buttressed by overt and covert support from Russia and Iran. A change cannot come without either Assad resigning or some forces physically removing him. But the million dollar question is who will replace Assad and whether this new regime will be able to quilt a government that will offer stability to the country. This quandary cannot be solved without all parties in this war agreeing to a solution.

As it is Syria as a country has been dismembered and destroyed. Over half of its population has been displaced and are now seeking shelters all over the world. Its cities are in ruins and it will take years and billions of dollars to rebuild this country. Nothing could please more millions of these displaced refugees if it took only fifty nine missiles to change this brutal regime. It will require more than missiles to change the face in Syria and the fate of its people.

Will destruction of ISIS bring an end to jihadist fight?

The first official knowledge of the existence of Islamic State of Iraq and Syria (ISIS) became public when the militant group wrested control of a large chunk of Iraq including the cities of Mosul and Tikrit and famously declared an Islamic Caliphate in the captured territory in June 2014. Their much touted victory over a thoroughly unequipped and decimated Iraqi army and retreating Syrian government forces made it possible for the Islamic radicals to find a home, and attract thousands to join the band from not only the Middle East but also from other parts of the world including Europe, America, and Asia.

At the beginning everyone among the political pundits and media dissed the idea of this militant group sustaining its gain let alone expanding the territory and military organization. Even President Obama called the group a JV team (a term used for Junior University sports teams), and did not direct any US resources toward containing or fighting this incipient band of militants. Meanwhile ISIS expansion and consolidation of territory in Iraq and Syria continued, and reports of hundreds of youths from Europe and Asia joining the band continued to pour in.

The wakeup call would not come until about a year later, when ISIS trained and inspired radicals carried out random bomb attacks, mass killings, and suicide missions in cities in France, Denmark, USA, Turkey, Tunisia, Yemen, and of

course Iraq. These activities doubled up when the group or people swearing affiliation to it launched indiscriminate attacks on civilians in non-military bases in European and US cities as well as Middle East, Pakistan and Bangladesh. The West's response to contain and defeat the nascent militant state was tentative, with US reluctant to have a ground force engaged in yet another Middle East battle, except for sporadic bomb attacks from air.

Dilly dallying on a sustained and determined approach by Western nations to contain and destroy ISIS partly happened because of unwillingness among most of these countries to get involved in another Iraq type war, and a feeling that such an entity did not pose an existentialist threat to them. Many political analysts and strategists argued that ISIS was an Arab problem and should be dealt with by the Arab nations. Strangely, many other non-Arab Muslims countries including Turkey had declined to get involved militarily on similar grounds.

It took some time for US and European countries including the non-Arab Muslim countries that ISIS was not just an entity to remain satisfied with establishing an Islamic Caliphate in the Middle East, but also more importantly was the sponsor and proselytizer of a concept based on a twisted interpretation of Quran and Sharia. This concept not only advocated expansion of its dream of Islamic Caliphate all over the Muslim world but also wherever Muslims are, and it considered everybody who opposed this concept whether followers of other religion or Muslims.

The concept of a state based on Islamic laws of Sharia and rigid interpretation of the religion is not new. But the campaign launched by ISIS and its followers and sympathizers was also in a sense existential. It is existential because the supporters believe that their ideology is one that every Muslim should live by. Ironically, although the ideology was born decades ago in one form or the other beginning with Muslim Brotherhood in the same geographic area, and was later followed by more extremists groups such as Taliban in Afghanistan and more famously Al-Qaeda in later years, ISIS (which broke away from Al-Qaeda) took it to new level by adopting Trotskyite tactics of mowing down opponents in a brutal manner along with conventional wars. They started to behead people they believed to be their enemies including all "non-believers", and encouraged and undertook suicide missions in non-military areas and indiscriminate killing of civilians in foreign soil. Their conquest of two cities of Iraq and proclamation of the Caliphate, an act that no other radical groups were able to do before, also fired the imagination and zeal of the romantic youths abroad who were either disenchanted with their environment or the lives they were leading. They joined ISIS in droves either because of their disenchantment or because they already had nurtured radical thoughts and temperament in them.

What we witnessed in Bangladesh in recent times in growth of religious radicalism and its manifestation in many forms is also not detached from this global spread of such extremism. Unfortunately however, our political leaders seemed to put

the blame on their political opponents for such violence whenever it occurred. Violence during election times and other political protests is not the same thing as those inspired by religious radicals. The goals of violence caused by established political parties are short term, but those caused by the religious radicals are long term goals. These are changing the country from its established principles to ones that are based on a different ideology.

We have had a variety of religious radicals sprouting in the country in last two decades, but none with the ferocity and viciousness of the groups who have been identified with some of the most violent acts of last two years. The worst examples have been the tragic happening of Gulshan and Sholakia. What is most revealing of the recent violent incidents is the identity of the perpetrators, who did not fit the usual profile of radical fighters emanating from religious institutions or from hard core religious background. They are youths drawn by a so-called ideal that has been able to draw many other youths like them from various parts of the world and imbued them with hate, intolerance and violence to spread that ideal.

Now that a sizeable chunk of the territory occupied by ISIS has slid out of its hands, and it is poised to lose control of its last stronghold in Syria, it may be possible that the group will finally retreat, and the so-called Islamic Caliphate might come to an abrupt end. But they will run and hide elsewhere. The ideology and promise they made to their followers will continue to attract and inspire other would be

militants and disgruntled elements worldwide. They may be deprived of a home base, but they will strive for another in a likely soft state elsewhere.

What will prevent the further spread of this new radicalism is lack of public support. No movement can last for long on intimidation, terror, and indiscriminate killing. No religion sanctions that. The current movement of the so called jihadists, if we can call it a movement at all, is rooted neither in Islam nor the vast followers of Islam. It is a false movement based on false interpretation of the religion and its doctrines. No movement without mass support can survive for long. While countries gear up to confront the menace of this radical group and take measures to stop its youth from falling prey to such ideas, alongside they will need to raise mass awareness about the falsehood of this radical thought and the danger confronting us all. In Muslim countries such as Bangladesh this will mean more reforms in our educational curricula and educational institutions focusing on teachings of religion, values of life, liberty, and freedom of thoughts. These will also need to be cast in the overall framework of transparency in governance, rule of law, and equality before law of all citizens in the country. May be we can see a better future free from violence for all our next generations if we strive together.

www.ingramcontent.com/pod-product-compliance
Lightning Source LLC
Chambersburg PA
CBHW031056180526
45163CB00002BA/856